Best wishes to Rebecca,
Elaine Thomopoulos
1/10/04

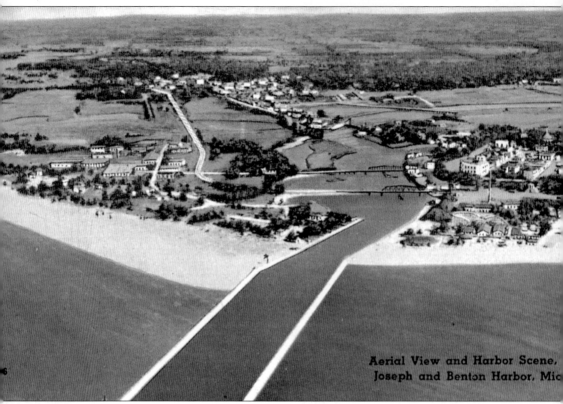

This post card shows an aerial view of St. Joseph and Benton Harbor. (Photo courtesy of Benton Harbor Library.)

The cover photograph features Main Street in Benton Harbor, c. 1934. (Photo courtesy of Fort Miami Heritage Society.)

IMAGES of America
ST. JOSEPH AND BENTON HARBOR

Elaine Cotsirilos Thomopoulos, Ph.D.

Copyright © 2003 by Elaine Cotsirilos Thomopoulos, Ph.D.
ISBN 0-7385-3190-1

Published by Arcadia Publishing,
an imprint of Tempus Publishing, Inc.
Charleston SC, Chicago, Portsmouth NH,
San Francisco

Printed in Great Britain.

Library of Congress Catalog Card Number: 2003112064

For all general information contact Arcadia Publishing at:
Telephone 843-853-2070
Fax 843-853-0044
E-Mail sales@arcadiapublishing.com
For customer service and orders:
Toll-Free 1-888-313-2665

Visit us on the internet at http://www.arcadiapublishing.com

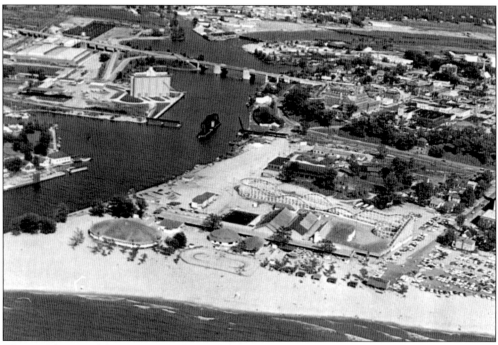

This aerial view of the twin cities shows the Silver Beach roller coaster in the right foreground and the bridges in the background. (Photo courtesy of Benton Harbor Library.)

Contents

Acknowledgments		6
Introduction		8
1.	Scenes of the Cities	11
2.	Commerce, Industry, Agriculture, and the Blossomland Parade	41
3.	Municipal Services, Houses of Worship, and Organizations	53
4.	Education, Culture, and the Arts	73
5.	Transportation and Communication	85
6.	Sports, Leisure, and Resorts	101
7.	House of David	117
Bibliography		126

Acknowledgments

Completing this book would not have been possible without the dozens of people who assisted me. Foremost, I appreciate the loving encouragement and red pencil editing of my husband, Nick. His true devotion revealed itself when he accompanied me every weekend to do research and gather photographs. His gentle understanding and great listening skills have made creating this book, as well as previous books and projects, possible. Also, I sincerely thank my children Marie Sussman, Melina, Diana, and Christopher, and my son-in-law, Mathieu Sussman, for reading the manuscript and offering valuable suggestions as well as support. My mother, Emily Cotsirilos, has also been a great help to me. The energy and love of my grandchildren, Lauren and Daniel, have given me welcome diversion.

What great people I met while doing the research for the book! They fascinated me with their stories of earlier years in Benton Harbor and St. Joseph, and offered photos, books, and videos from their institutional and personal collections.

Relentlessly, practically every day for a couple of months, I searched the photographic and archival collections of the Fort Miami Heritage Society, Benton Harbor Library, and Maud Preston Palenske St. Joseph Michigan Library, many times visiting all three facilities in one day. Without being able to reproduce the wonderful vintage photos included in the archival collections of these institutions, it would not have been possible to complete the book. Their staff offered me patience, friendliness, and valuable assistance. My sincere thanks to Kenneth Pott, who encouraged me to write the book, Marjory Towne, who gave me guidance and listened with interest to the stories I discovered about the twin cities, and to Matthew Anderson, who lugged out dozens of photo boxes without complaint day after day, answered questions about the early history of the twin cities, and reviewed the book. Thanks also to Mary Kynast and the marvelous staff of the Maud Preston Palenske Library, who patiently brought out the numerous photo files and helped me find books. Ann Vandermolen of the Maud Preston Palenske Library also guided me with her knowledge of St. Joseph. Jill Rauh of the Benton Harbor Library not only allowed me to reproduce photos from the library's collection, but also gave me valuable technical support. She is a real community asset, excellent in giving advice and finding resources. Also, the bibliography she included on the library's web site is outstanding. Thanks also to Carole Richardson of the Bridgman Public Library for her assistance, and to Maura Brown for her wise editing of the book.

Morton House Museum (Miriam Pede and Denise Reeves), Cornerstone Chamber of Commerce (Pat Moody, Veronica Putt, Regina A. Ciaravino), Sarett Nature Center (Chuck Nelson), Mary's City of David (Ron Taylor), the *Herald-Palladium* (Dave Brown), and the Chicago Bulls also generously allowed me access to their photographic collections. Pat Moody allowed me to reproduce his many excellent photographs. These community agencies not only supplied copies of photographs to be used in the book, but they also provided information about

their organizations and the community. Thanks also to the Writer's Group that meets at the Lincoln Township Library. With their astute comments and encouragement, they are helping me develop my writing skills.

My interest in writing this book can be traced to the research, lectures, and booklet we produced on the Greeks of Berrien County, a project of the Berrien County Historical Association. I learned much from Leo Goodsell, Executive Director, and Robert Myers, Curator of the Berrien County Historical Association.

Others who have so graciously helped me by editing the book, providing photographs from their personal collections, or videos, books, or information include: Annunciation and St. Paraskevi Greek Orthodox Church, Reverend Donald and Louise Adkins, VeLois and Bennie Bowers, Gladys Peeples Burks, Maura Brown, B.A. Brittingham, Reverend James Childs, Marjorie S. Clemens, Michael Eliasohn, Judy Fogarty, Richard Grau, Roy Hall, Cathy Donoho Helsham, Rich Hensel, Mike Kerhoulas, Paul and Jan Koehler, Mary Kynast, Jesus Lopez, Ben Mammina, Marilyn Pape, Delores Parr, Alva Patterson, Barbara Peeples, Susan and Natalie Plee, Rich Ray, Lidia Richards, Bernard Rizzo, William Seabolt, Kate Spelman, Roy and Elaine Shoemaker, Dr. Joseph Shurn, Denise Tackett, Sam Watson, Christine Wright, and Seymour Zaban.

I did not anticipate what an awesome and heartwarming journey awaited me when I first started doing research for the book. I felt the pain and the joy of the early pioneers through an exploration of their photographs, books, letters, and newspaper articles. Also, I saw firsthand the current accomplishments and enthusiasm of the citizens of St. Joseph and Benton Harbor. It has been a privilege to participate in this community-wide endeavor.

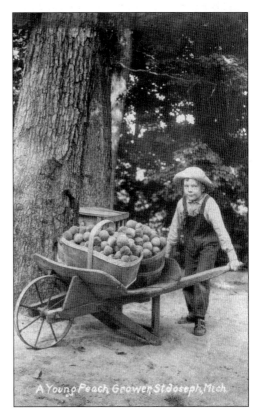

Homegrown Southwestern Michigan peaches, with their fragrance and sweetness, are the best! The peach industry started in 1839 when Captain Curtis Boughton of St. Joseph shipped peaches to Chicago. It is believed that he shipped the peaches of B.C. Hoyt. When he saw what fruit-starved Chicagoans paid for them, the enthusiastic Captain Boughton shipped peaches from his own orchard the following year. Others joined him in production of peaches, including the Mortons, George Parmelee, and Smithe and Howell, bankers from Cincinnati, Ohio, who leased 70 acres from the Mortons, and whose orchard was known as the "Cincinnati Orchard." (Photo courtesy of Fort Miami Heritage Society.)

INTRODUCTION

Two distinct communities which share equally vibrant histories, the twin cities of St. Joseph and Benton Harbor possess a rich heritage rooted in the struggles of the adventurers and pioneers who first came to this area of sand, swamps, and forests. These adventurous, hardy, and persevering men and women tamed the wilderness and developed its thriving agricultural, manufacturing, and tourist industries. One of the most daring men to come here was the explorer Rene-Robert Cavalier de La Salle, a former Jesuit novitiate. He risked his life in the wilds of America to claim land for France and to become rich through trading. He built the first ship to sail the Great Lakes, the *Griffon*, and sent her to deliver furs to Montreal. After the *Griffon* departed, he traveled with three friars, ten Frenchmen, and a Mohican hunter in four large canoes along the treacherous coast of Lake Michigan to reach the mouth of the St. Joseph River. (LaSalle named it the River of the Miamis after the Indians who lived there, but it was renamed the River of St. Joseph.) They arrived on November 1, 1679. Although he had given the men who sailed the *Griffon* orders to rendezvous with him at the mouth of the river, the *Griffon* never arrived. While they waited in vain for her, his men built Fort Miami, a 40-by-80 foot structure, near the mouth of the St. Joseph River.

Disappointed that the *Griffon* did not arrive, LaSalle continued his explorations by canoe, traveling to the mouth of the Illinois River and back. He then traveled for 65 days to Montreal—on a horrendous and thankless journey. He faced hardships and terror, including half-frozen marshes and pursuit by Indians. Moreover, when he reached Fort Frontenac in Montreal, he had to face losses of property and the desertion of most of his men.

To make things worse, on his return to Fort Miami, he discovered the charred remains of the fort, which had been burned by his own men. Undaunted, he continued his journey. He left five of his men to watch the stores while he traveled to Illinois. Imagine his delight when he returned to discover that his men had rebuilt the fort, and were in the process of building a ship.

For the next 150 years, only Indians, French voyageurs, trappers, and soldiers came to the wilderness. Another adventurer, William Burnett, a trader from New Jersey, established a trading post some time between 1775 and 1782. It included a warehouse near the mouth of the St. Joseph River and a log store and home less than two miles up the river. He married a capable and business-minded Indian named Kawkena, the sister of the principal chief of the Potawatomis. Pack mules, sloops, and schooners brought his trade goods from Detroit and Canada, which he noted in a letter included "Rum, powder, and Ball." The Potawatomi Indians supplied him with furs and fresh produce such as corn. He disappeared in 1812, possibly in the Fort Dearborn massacre. According to various accounts, the trading post continued under the direction of either his son or his wife for about 11 years after his death, and then it too disappeared.

Other settlers did not make the difficult journey from the east coast until the late 1820s and 1830s. Public land sales afforded them an opportunity to buy an acre for $1.25, and the opening

of the Erie Canal made it easier to travel to the frontier of Michigan. They also found encouragement because of the treaty made in 1828 at the Carey Mission near Niles. In this treaty, the Potawatomi Indians, who occupied the area at that time, ceded the area to the territorial government. More encouragement for settlers came when Michigan became a state in 1837.

Hardy sailors also traveled to the mouth of the St. Joseph River, seeking refuge from furious Lake Michigan storms. In the fall of 1827, Captain Hinkley entered the harbor to weather a storm and stayed for the winter. For shelter, he and his men built a log home. He sailed back to Chicago, but returned, believing that the area near the mouth of the St. Joseph River offered more opportunity than Chicago. He and his sons became pioneer lumbermen, sawmill operators, and much later, basket and barrel makers. The early local industries also included farming, logging, and shipbuilding.

Early St. Joseph settlers also included Captain Ed Smith; Calvin Britain, a teacher and businessman; and August Newell, who built one of the first hotels and taverns in St. Joseph. St. Joseph was first known as Saranac and then Newburyport. Calvin Britain laid out the town of Newburyport, which now lays buried under the sand. In 1833, Newburyport changed its name to St. Joseph. A year later, with 27 houses, it incorporated as a village.

After St. Joseph's first village meeting in 1834, a $400 tax was levied. However, times were hard, and the villagers could not afford the tax. Instead they were permitted to dig tree stumps from the village streets for which they were paid 25¢ per stump.

In 1834, word of a railroad coming caused wild speculation and exorbitant prices with lots going for as much as $500. Unfortunately, the railroad did not come and many people moved out of town. The hardier settlers stayed, however, and in 1868, ground was broken for the Chicago and Michigan Lake Shore Railroad Company. In the year 1891, another milestone was reached. St. Joseph became a city.

The new city rejoiced when the county seat was transferred from Berrien Springs to St. Joseph. Difficult transportation was one of the reasons St. Joseph pushed to change the county seat from Berrien Springs to St. Joseph. A road repairer reported, "I hereby affirm that I have done the work on the mud hole between Saint Joseph and Berrien and that the mud hole is fifteen miles long." There had always been a rivalry between the St. Joseph and Benton Harbor since their beginnings. (L. Benjamin Reber, in his book, *History of St. Joseph*, relates, "Skating parties from the two towns frequently met on the river when skates were removed and used as weapons of offense and defense.") However, in this case, Benton Harbor set aside that rivalry and pitched in with votes to help St. Joseph become the county seat in 1894.

Benton Harbor's first settlers were Eleazar and Joanna Morton. Eleazar purchased 160 acres of land in Benton Township, and in 1836, he and his wife and children moved into a log cabin on a site located in the middle of present-day Main Street. The site not only housed his family, but also served as a wayside inn for weary travelers, which he welcomed gladly into his house. In 1849, the family moved to 501 Territorial Road. Henry Morton, one of Eleazar and Joanna's ten children, helped his father build this home and he, his wife Josephine, and their children lived with his parents. Henry also teamed up with his father to plant fruit, which they sold in Chicago.

Benton Harbor blossomed because of the construction of a mile-long canal, which made it possible for boats to come from Lake Michigan into their central business district, when before they did not have good access to the river. Henry Morton, along with Charles Hull and Sterne Brunson, undertook the construction of the canal through the wetlands between the river and future Benton Harbor.

The town was founded as Brunson Harbor in 1860, named after Sterne Brunson. In 1862, the canal opened, and a year later the dry land beneath the bluff was plotted into 50-foot lots. The canal helped in the development of the area, enabling the shipping of fruit and manufactured goods. Brunson Harbor became Benton Harbor in 1865, named after a senator who had supported Michigan's bid for statehood. This name was better than its nickname Bungtown, given because a business in Benton Harbor manufactured bungs, or stoppers for barrels. It became a village a year later.

By the turn of the century, tourists traveled from Chicago via steamboat, railroad, and car to escape the sweltering heat and crowded city—delighting in the cool breezes off Lake Michigan. They enjoyed luxury resorts and hotels; frolicked at the beaches; relished the homegrown fruit and vegetables; partook of the smelly but healthful mineral baths which cured "rheumatism, nervous disorders, and poor circulation"; and went to amusement parks like Silver Beach in St. Joseph and the House of David in Benton Harbor.

In 1903, Benjamin and Mary Purnell organized the House of David, a Benton Harbor religious colony. The amusement park they built a few years later on their 500 acres included a zoo, miniature trains which traveled a mile around the park, hot-rod cars for children, music, and baseball by the bearded House of David baseball team. Today the area continues to be a mecca for tourists from Chicago.

In 1891, with a population of 3,692, Benton Harbor submitted an application to become a city, setting their boundary at the river. This created an uproar in St. Joseph, since they believed their city boundary extended to Colfax, across the river. To resolve the dispute, the two villages made a futile effort to merge. However, they could not come to any agreement about the name of the combined city. The governor gave each city a separate city charter.

Many of the area's first brave settlers originated from the east coast, mainly New York or greater New England. However, even in the early years, a diverse group settled the area around the twin cities. Sixteen African-American freemen lived in St. Joseph Township during 1840, according to the U.S. Census. By the 1860s, settlers in the twin cities and surrounding areas included those of French, Irish, German, and Swedish descent. By the turn of the century, many eastern and southern European immigrants made their way to the twin cities. Some came to farm, but many came to work in the developing foundries and manufacturing industries. In the United States, they found refuge from the economic hardships or political repression of their home countries. In the 1940s and 1950s, African Americans and Caucasians from the South came in large numbers to find work. Some came as migrant farm workers and stayed.

The development of the twin cities came with a lot of sacrifice for the first settlers, as well as for the European immigrants and African Americans who followed. A.E. Chancey, in his book, *Berrien County: A Nineteenth Century Story*, points out the difficulties of the early years, "They performed a miracle in such a godforsaken place, among the rattlesnakes and mosquito-infested frog ponds and sand dunes."

He explains: "The journey for the pioneers from the Eastern Seaboard to Berrien County was a hazardous undertaking, especially for the wives and mothers. They made the great sacrifice when they left comfortable homes, parents, brothers and sisters, to go on the long trek in a covered wagon over the intolerable roads: through the mountain passes; then on a canal boat nearly four hundred miles; then on a ship from Buffalo to Detroit. Again they either rode in a covered wagon or stage coach over more intolerable roads, some two hundred miles to their destination—a one-room log cabin surrounded by a forest. There were births and deaths en route. The loved ones were wrapped in blankets and buried in shallow graves."

He describes the early housing and difficult life: "With a few pots and pans the simple meals were prepared over the open fireplace. The bedding was a tick filled with boughs or dried grass. In these same cabins they brought babies into the world. Many of them passed on to another world, and frequently the mother accompanied them on the way. . . . The people of Berrien County owe a debt of gratitude to the pioneers who migrated to the county during the Nineteenth Century. Many of them sacrificed their lives to create the great county in which we now live."

One
SCENES OF THE CITIES

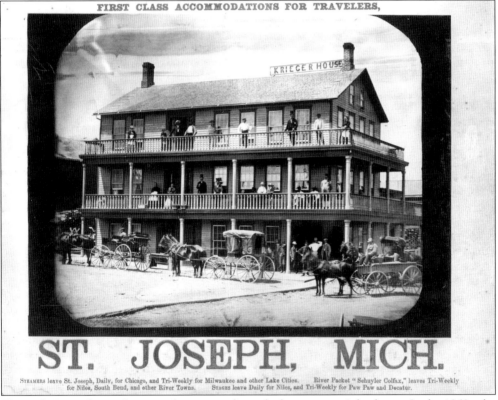

The early "wayside inns" were nothing more than a bed in a pioneer's log home. In the 1860s, the Krieger House served travelers who came by boat or stagecoach. An advertisement at the bottom of this poster announces, "Stages leave daily for Niles, and Tri-Weekly for Paw Paw and Decatur." Traveling by coach over bumpy roads wasn't an easy trip. An early pioneer described the roads as "mud and mire." Sometimes male passengers pushed the coach out of the mud and the ladies dirtied their boots and skirts when they had to disembark. According to Ella Champion, in *Berrien's Beginnings*, "Often as many as fifteen stage coaches drawn by four horses came into St. Joseph in one day.... The arrival of the stage was announced by the blowing of a horn by the driver, perched high on the front of the coach." (Photo courtesy of Fort Miami Heritage Society.)

Eleazar and Joanna Morton were the first settlers in Benton Township. In the preface of *Reminiscences of the Lower St. Joseph Valley*, Victor M. Gore describes Eleazar Morton as "one of the most prominent men in the county—a man whose counsel was sought by all his neighbors . . . a man of commanding presence, strict integrity and a strong will. He was an author of some note and for years a correspondent of the *New York Tribune*. He assisted all who came to him in distress."

Henry Morton, the son of Eleazar and Joanna Morton, was one of the three Benton Harbor men who made the canal possible and opened the way for the development of the city. He, like his father, welcomed guests to the white home on the hill at 501 Territorial Road. The civil engineer who was contracted to design and build the canal, Martin Green, lived with his family at the Morton home for two years while the canal was being built. Henry's wife, Josephine, died as a result of complications during childbirth.

Their son, James Stanley Morton, was only nine years old at the time. James Stanley Morton, like his father and grandfather, became involved in the development of the city. He married Carie Heath of Benton Harbor. He formed a partnership with Andrew Crawford and J.H. Graham to engage in the steamboat business between the ports of Benton Harbor and Chicago. He also helped organize the Benton Harbor Improvement Association which brought industry to the city. (Both photos courtesy of Fort Miami Heritage Society.)

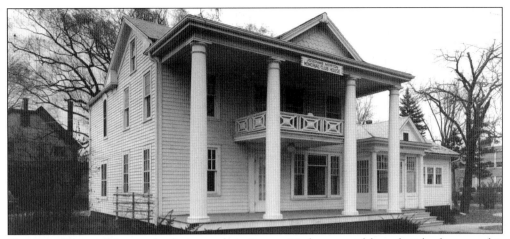

Eleazar and Joanna Morton, the first to settle in Benton Harbor, moved from their log home to this home at 501 Territorial Road in Benton Harbor in 1849. Henry Morton, one of Eleazar and Joanna's ten children, helped his father build the home where he, his wife Josephine, and their children lived with his parents. Morton would receive travelers who stopped at this home because it was terminus of Territorial Road, the only road going back and forth to Detroit. Prior to the laying of the road, the only way to get to Detroit by land was by following an old Indian trail by horseback. The Morton House is now a museum dedicated to Josephine Morton and maintained by the Benton Harbor-St. Joseph Federation of Women's Clubs, an association of 12 women's clubs. The Federation of Women's Clubs (then called the Benton Harbor Federation of Women's Club) was organized on February 18, 1915, with 13 clubs represented. Recognizing that there is strength in numbers, they joined together to create a strong force in the civic life of the city. During World War I, they encouraged planting gardens for food, gave lessons in the canning and preserving of food, provided volunteers for the Red Cross, and created soup kitchens during the influenza epidemic of 1918. Where there was illness in a family, they provided food. They raised funds for the Roosevelt Monument in Roosevelt Park. They also became active in welfare work during the depression. In 1942, J.S. Morton deeded the Stanley Morton House to the Federation of Women's Clubs. It was first used as its clubhouse and for receptions. It is now maintained as a museum, furnished with period furniture and with knowledgeable docents giving tours—a treasure of the community. (Photo courtesy of Fort Miami Heritage Society.)

The Jakways built this cabin c. 1840 at 1280 Hillandale Road in Benton Harbor. The first settlers led a hard life, often starting out in one-room cabins. Indoor plumbing did not exist and the women cooked over a fireplace. Wildlife, including bears, surrounded their abode. Some suffered the ague (or malaria), which caused chills, violent shaking, and fever. (Photo courtesy of Fort Miami Heritage Society.)

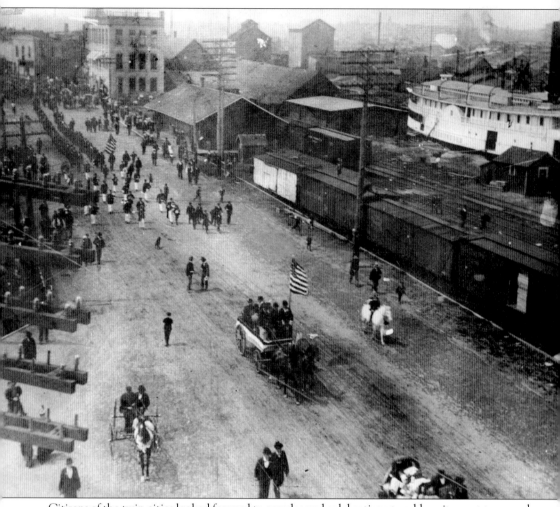

Citizens of the twin cities looked forward to parades and celebrations to add excitement to everyday life. This parade was probably held to send soldiers off to the Spanish-American War. It brings to mind the parade and celebration of 1894, when news came of the vote in favor of moving the Berrien County Courthouse from Berrien Springs to St. Joseph. Benton Harbor votes made a big difference in the outcome of the election. A.G. Preston Jr., in *Berrien County Courthouses*, describes what happened when they received the news: "St. Joseph went wild and after a short demonstration there, a crowd of the excited citizens marched from St. Joseph to Benton Harbor. Upon their arrival, a mammoth bonfire was built on the four corners for their reception." Preston reports that an old handbill inviting people to the Grand Celebration on April 4th said, "Come in team, on horseback, on foot, anyway to get there, with flags and other decorations. Two halls—the Academy and Preston's Rink—will be open for the crowds. Dancing in the former place. Music by the LaPorte, Elkhart and Twin City Bands. Grand street parade! Fireworks in the evening!'" Preston goes on, "The committee decreed that the line of march should include the following: Police, marshall and his aides, band, Grand Army of the Republic, Sons of Veterans, other societies, Independent Order of Odd Fellows, Knights Templar, Master Masons, Grand Lodge, F & AM Hon. O.W. Coolidge, Rev. H.W. Davis, supervisors and county officers, distinguished visitors, attorneys, mayor and alderman of cities, presidents, and council of villages and citizens of Berrien County." When a new courthouse was built in 1967, the old courthouse was torn down. (Photo courtesy of Fort Miami Heritage Society.)

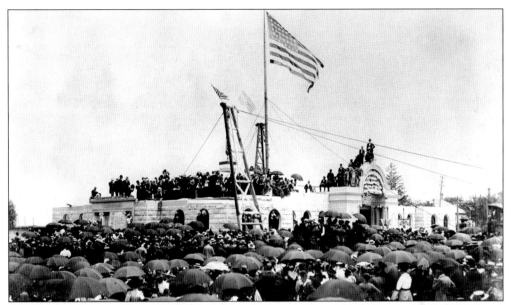

The laying of the cornerstone for the St. Joseph County Courthouse on July 4, 1895, by Grand Lodge Officers of the F & AM brought out a huge crowd. They also celebrated when the records were transported to St. Joseph by more than 30 teams of horses and oxen from Berrien Springs. Since the courthouse had not yet been completed, the court was housed at the Music School. (Photo courtesy of Fort Miami Heritage Society.)

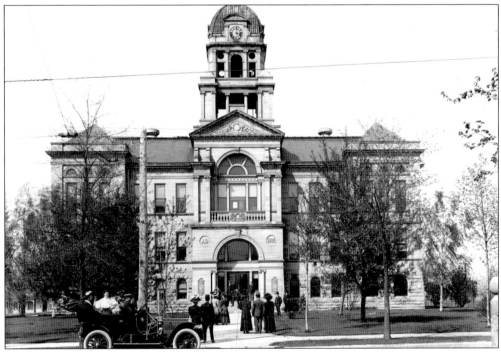

This elegant courthouse replaced the one in Berrien Springs. The tower was later removed, and finally the whole building was demolished to make way for the new courthouse. (Photo courtesy of Fort Miami Heritage Society.)

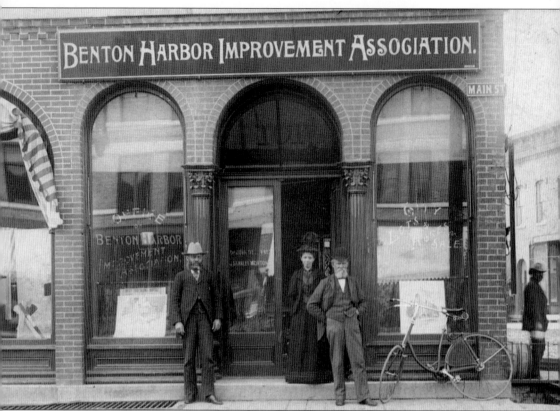

The Benton Harbor Improvement Association, founded in 1891, brought new growth to the city. The officers were Dr. John Bell, President, and J.S. Morton, Secretary. The map in the left window shows lots on the east side of the town. According to notes made by J.J. Dicerman in 1925, "Map on the right window is a proposed hotel site. The hotel plans were made by Chas. E. Ildsley of St. Louis, who was engaged for the work by Peter English. Peter English built the Premier Bath House, a mineral bath. He used an old discarded oil well, put in a pump and thus started the bath house." (Photo courtesy of Fort Miami Heritage Society.)

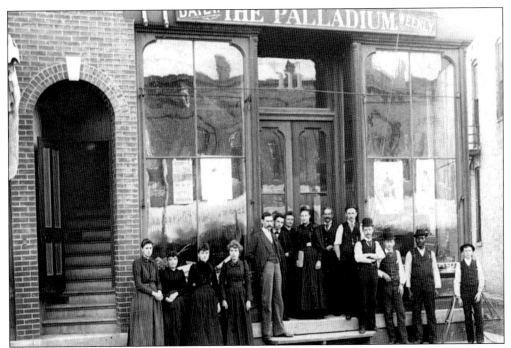

The staff of the *Palladium* newspaper pose outside their office in Benton Harbor. According to J.S. Morton, it was the first newspaper in town. L.J. Merchant, owner and publisher, established it in 1868. The paper's motto was, "Safeguard of Liberty." It had several publishers and editors in the years following, with F.R. Gilson and Fred A. Hobbs making it a daily paper in 1886. After Mr. Hobbs retired and Mr. Gilson died, it was sold to Mr. J.N. Klock and S.R. and W.J. Banyon. More sales and mergers followed. At any rate, the current *Herald Palladium* can trace its roots to the 1868 *Palladium*. Another paper currently published in the twin cities is the *Benton Spirit*. This monthly reports on the good news of the community and takes an active role in organizing community events. (Photo courtesy of Fort Miami Heritage Society.)

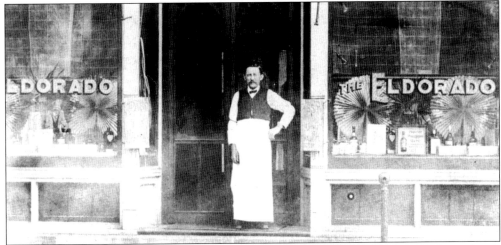

The El Dorado Tavern on State Street in St. Joseph, pictured c. 1896, welcomed thirsty locals and tourists. In the early days, gentlemen often greeted each other with the phrase, "Do you want to go have a drink?" (Photo courtesy of Fort Miami Heritage Society.)

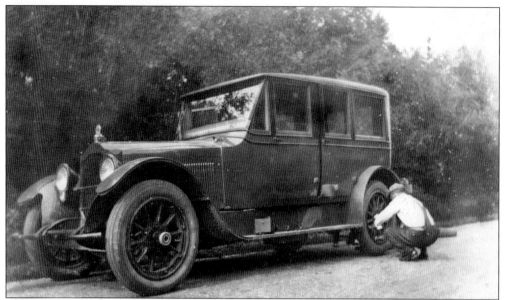

Changing a tire, as this gentleman is doing, was very common in the early days of automobiles. In fact, anyone taking a long trip was wise to take spares. (Photo courtesy of Fort Miami Heritage Society.)

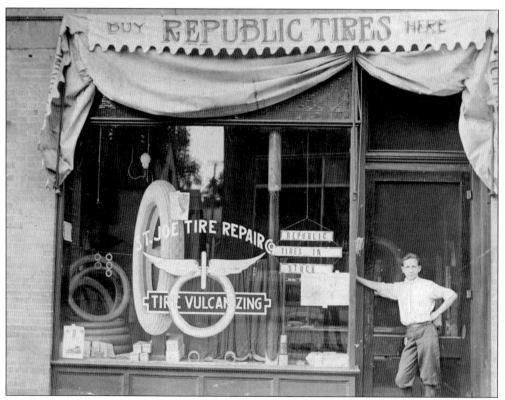

Republic Tire of St. Joseph must have done a lot of business at a time when blow-outs were very common. (Photo courtesy of Fort Miami Heritage Society.)

The Vincent Hotel used to occupy this building, which now houses the Southwest Michigan United Way. In prohibition times, crime boss Al Capone often stayed at the hotel. The access to southwestern Michigan grapes and the willingness of residents to make bootleg liquor for him made Southwestern Michigan an important part of his operation. Eleanor Anderson relates an interesting story about him in an article of the "Fort Miami Heritage Newsletter." Before he was sentenced to Leavenworth Prison on tax evasion, he planned a big party for his Chicago friends. He didn't care that the Rose Room was already booked by a women's group who were organizing a twin cities chapter of Epsilon Sigma Alpha Sorority. The management gave him the room, along with the decorations intended for the ladies' meeting. Adding insult to injury, Capone also usurped the singer and pianist they had hired. (Photo by Pat Moody of the Cornerstone Chamber of Commerce.)

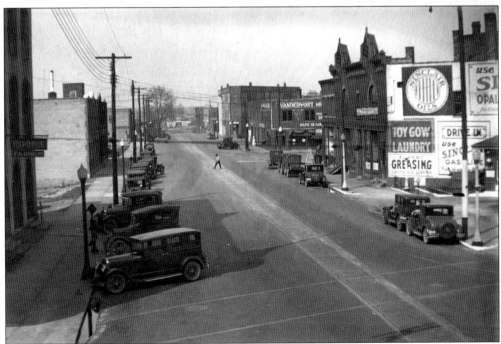

This is Water Street in Benton Harbor, showing Toy Gow Laundry, the Sinclair Station, and Vandervort. (Photo courtesy of Fort Miami Heritage Society.)

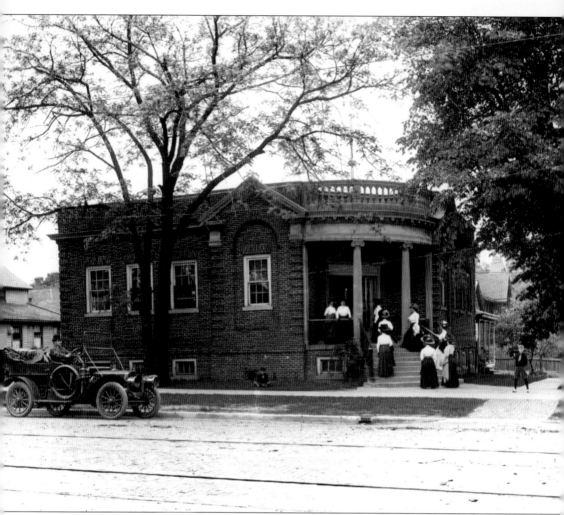

The generosity of Andrew Carnegie enabled the construction of the gracious old St. Joseph Library in 1904. William Augustus Otis designed the building and Max W. Stock was the contractor. The old library still stands and is home to Allegretti Architects and WNUB TV. Because of the need for larger quarters—and thanks in great part to the generosity of Fred Preston—the library moved to its present location at 500 Market Street. Residents carried books from one site to the other in bags and wagons, according to librarian Mary Kynast. In 1981, the building was expanded and in 1997–1998 it was renovated and expanded again.(Photo courtesy of Fort Miami Heritage Society.)

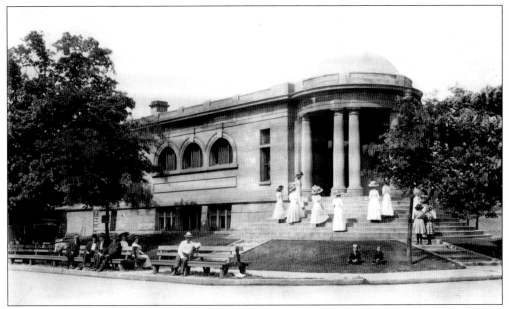

A bevy of beautiful women dressed in white dresses and wide-brimmed hats highlight the grandeur of the old library. The library was built in 1903, through the generosity of Andrew Carnegie, who also donated the funds to create libraries throughout the country. One of the noted highlights of the building was that it had running water throughout. When it opened, the library had 3,500 books on the shelves. An interesting anecdote is reported in the current Benton Harbor Public Library web page, "In 1923 head librarian, Theodosia Falkingham, on behalf of the women patrons, requested that the city remove the park seats outside the library because the area had become a paradise for tobacco spitting loafers and a convenient place for alcoholic imbibing gentry to sleep off their jags. Also, 'painted ladies' plied their trade in the area." The library built a new facility because it needed more space. (Photo courtesy of Fort Miami Heritage Society.)

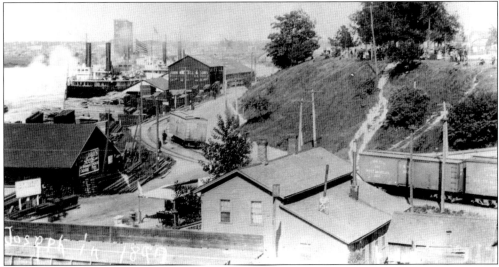

This photo of the St. Joseph Harbor dates from 1897. The arboretum is now to the left and the band shell and firemen's monument are on top of the bluff. (Photo courtesy of Fort Miami Heritage Society.)

Hattie A. Schwendener, M.D. came from Ohio at the turn of the century. A trailblazer, she was one of the first women doctors in Berrien County. She contributed her talents to the twin cities not only as a respected doctor, but as a charter executive board member of the YWCA in St. Joseph. The YWCA brought many worthwhile programs to the twin cities area, beginning in the early 1900s. This included a reading group for women factory workers, tourist aid, and programs for children. Another trailblazer was Dora Whitney, who in 1906 became the first practicing female lawyer in Berrien County. She continued to practice law until 1960. She raised four children, yet still had time to devote herself to various community activities, including the Women's Temperance Union, Women's Society of Christian Service at the Methodist Peace Temple, the Daughters of Ossoli, and the Order of the Eastern Star. (Courtesy of the Fort Miami Heritage Center.)

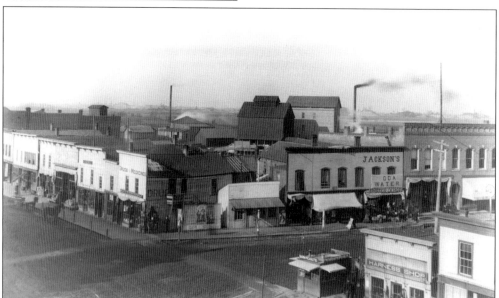

This is Benton Harbor's Four Corners looking north. To the right is the harness shop. On the corner is Hopkins Drugs and Medicine, then probably a barber shop (note the poles). In the white building are Jackson's and the Oyster Depot. One can see the industrial development of the city in the background, and also see the farmland further out. (Photo courtesy of Fort Miami Heritage Society.)

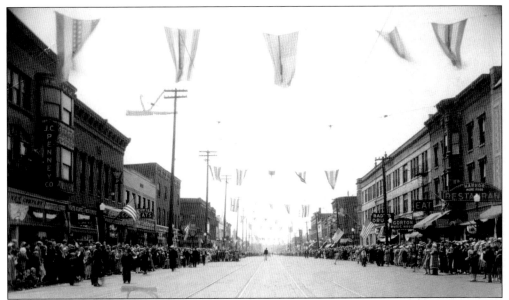

Looking south on Main Street in Benton Harbor, c. 1935, it seems as if the city is preparing for a parade. On the left side of the photograph, from left to right are J.C. Penney's, Meats Atlantic and Pacific, and Moutsatson's Good Eats. On the right from the edge of the photo is Harbor Restaurant and Gorden's. Down the street is Sears. (Photo courtesy of Fort Miami Heritage Society.)

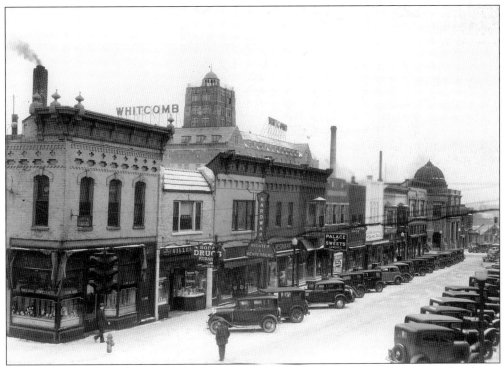

This photo of downtown St. Joseph shows the Whitcolm Hotel in the background. Also in business were Iaggi Jewelers, Gillespie Drug Store, Richter and Achterberg Hardware Store, Palace of Sweets, and Florsheim Shoes. (Photo courtesy of Benton Harbor Library.)

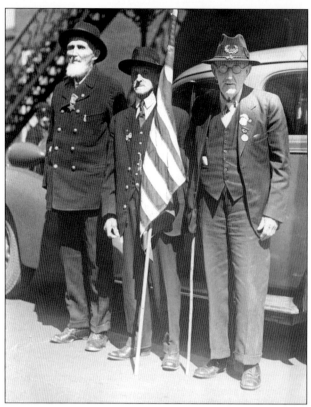

These Civil War veterans, Nelson Wood, C.B. Holmes, and James Brant, are honored by the community. Note the symbol of the Grand Army of the Republic (GAR), a veteran's organization, on Brant's hat. The GAR helped the veterans secure benefits and also held periodic reunions. James Pender, in his 1915 book, *History of Benton Harbor*, reports that in 1885, soldiers and sailors had a grand reunion at Benton Harbor which was attended by 25,000 people. (Photo courtesy of Fort Miami Heritage Society.)

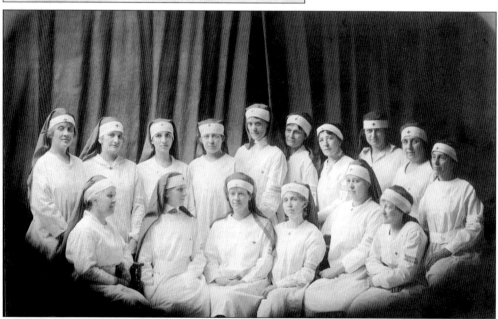

These women of the Red Cross made bandages during World War I. They wear armbands noting "surgical dressing." Similar Red Cross units were also organized throughout the country during World War II. Women helped in the war effort by doing volunteer work such as this, as well as working in industry and on the farms. (Photo courtesy of Fort Miami Heritage Society.)

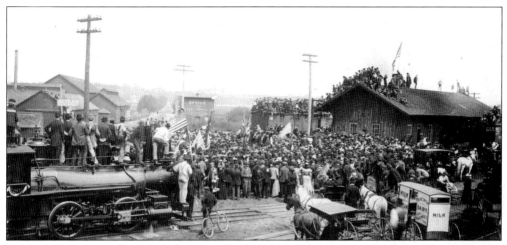

In May, 1898, practically the whole town turned up at the depot to give their best wishes to Benton Harbor Company I Militia as they were leaving to fight in the Spanish-American War. However, this photo might well have been taken when they returned. A local correspondent, James Pender, of the *Chicago Times Herald* wired this under the date of September 4, 1898, (the war lasted less than four months): "A committee and two bands and thousands of people met the boys at the depot, and when they disembarked the scene that followed was both pitiful and enthusiastic." He describes the banners and rejoicing, but also paints a glum picture of war: "The returning troops presented a striking contrast to the original 86...Of the 86 who went to Cuba, 58 came back tonight, eight are in the hospital at Montauk Point, one is still sick in Cuba, one died on a transport and was buried at sea and nine others are at home, having come back at different times on account of disability. (Photo courtesy of Fort Miami Heritage Society.)

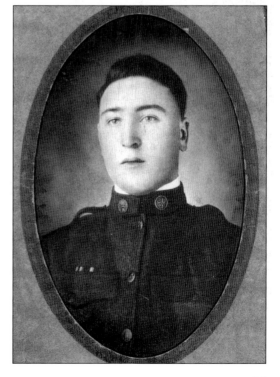

Joseph Ross Mammina served in the U.S. Army during World War I. Joseph emigrated from Sicily to the United States in 1903. In 1915, Joseph's father, mother, and six siblings came to Coloma, where they had a grocery store, and eventually settled in Benton Harbor. Joseph and his brother Ben set up a successful trucking business. They hauled fruit to Chicago and hauled back durable goods, including furniture for immigrants moving to the farms of southeastern Michigan. As the business grew, the brothers bought property at 405 Territorial in Benton Harbor. Their father, Benedetto, opened Mammina's Bar at the same address after prohibition. The Mammina family lived and worked in the area of Benton Harbor called "Little Italy." This area, including Territorial downtown and north along Paw Paw, was settled primarily by Italian immigrants, as well as Jews and Russians, who had come to the United States at the turn of the century. (Photo courtesy of Benton Harbor Library.)

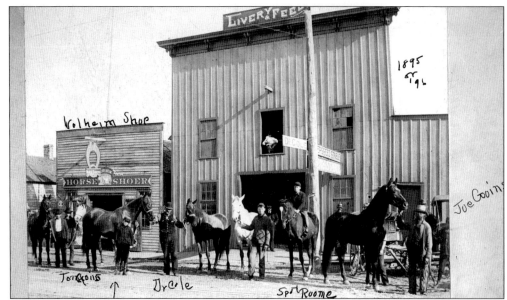

The community depended on Benton Harbor's Volheim Horseshoer and the Livery and Feed, c. 1895. Even before 1900, the state of Michigan had a State Board of Examiner of Horseshoers and issued permits that attested to the skill of this important work. The community also depended on Dr. Cole, a veterinarian. He is shown holding the two horses. (Photo courtesy of Fort Miami Heritage Society.)

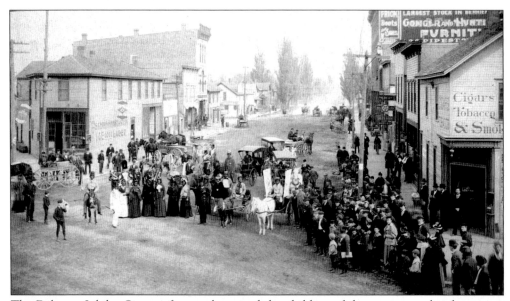

The Delsante Jubilee Singers, former slaves and the children of slaves, sang at this downtown parade in November of 1895. Two male singers in the front wear stove-pipe hats. The band in back of the singers is Caucasian, as is most of the audience, except for a few African-American men. Jubilee Singer groups were popular entertainment. A Jubilee Singer group was organized at Fisk University, a southern African-American university, with the intention of raising money for the school. They sang spirituals, telling of the trials and travails of slavery, and continue touring today. (Photo courtesy of Fort Miami Heritage Society.)

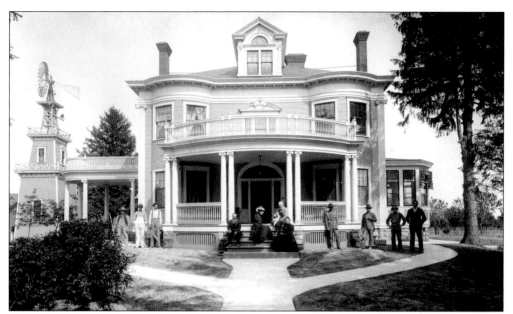

Here the residents pose outside the Handley Home. Note the porch, which was often used as a "sitting room" in these years. Windmills, before the time of running water, pumped water into the home. Lumber was plentiful in early years, and at the turn of the century, most of the elegant homes of captains, merchants, and professionals in the twin cities were made of wood. (Photo courtesy of Fort Miami Heritage Society.)

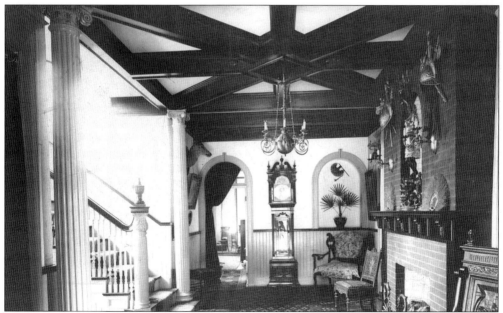

The interior of the Handley House on 2837 South Lakeshore, c. 1901, typified an elegantly decorated Victorian home, revealing the taste, interests, and prosperity of its occupants. Objects were lovingly and artfully arranged. Note the bear rug on the floor, helmets above the fireplace, grandfather clock, Grecian columns, piano, upholstered chairs, and fireplace. (Photo courtesy of Fort Miami Heritage Society.)

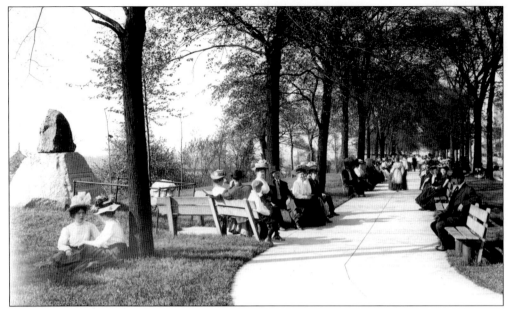

Strolling ladies and gentlemen enjoyed a leisurely walk by Lake Bluff Park, c. 1885. The land for the park was donated by Junius Hatch. This is quite a change from the wilderness that greeted LaSalle when he arrived at the mouth of the St. Joseph River in 1679. LaSalle, who fearlessly explored the rugged wilderness, met an early death at the hand of his own men when they mutinied against him in Texas. The plaque to the left honors him. (Photo courtesy of Fort Miami Heritage Society.)

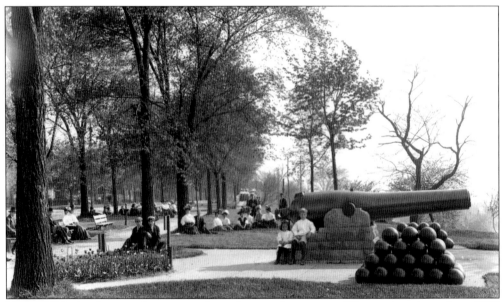

The GAR helped secure this cannon from the war department. The cannon dates from 1865 and was removed from the U.S.S. *Marion* in 1876. At the unveiling ceremony on July 4, 1897, Captain John Freud acted as Grand Marshal. Mayor Starr spoke for the city and John Lane for the GAR. The cannon serves as a memorial to those who died in the Civil War. It was fired during early Fourth of July celebrations. (Photo courtesy of Fort Miami Heritage Society.)

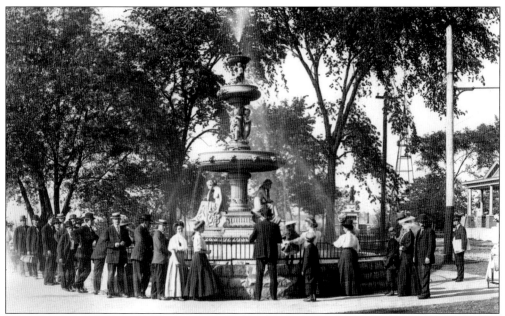

The Maids of the Mists Fountain, a well-known St. Joseph attraction, was originally built in 1872–1873 for the Inter-state Industrial Exposition Building in Chicago, where it remained until 1891. With much fanfare, the fountain was installed in 1892. By the early 1970s, the Maids of the Mist had suffered severe deterioration, and it was dismantled and put into storage. The Fort Miami Heritage Society restored the fountain and rededicated it in 1974. (Photo courtesy of Fort Miami Heritage Society.)

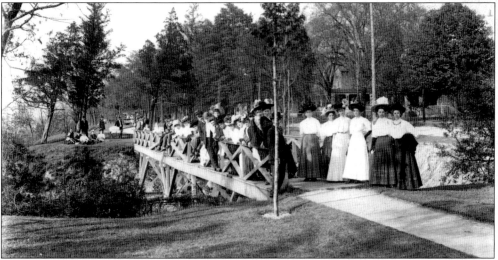

Elegant ladies walk over the bridge over the gulch in Lake Bluff Park. By the end of the century, clothes for women had become more liberating, without the hoop skirts and bustles. An early pioneer, Albert S. Wallis, explains the hazards of women's clothing in the middle of the nineteenth century, "The ladies could only walk two abreast on the walk as the voluminous hoop skirts took up the balance of the space and with big bustles and large flower garden hats which often had a long stiff feather running aft, it made it sometimes dangerous for others around them." (Photo courtesy of Fort Miami Heritage Society.)

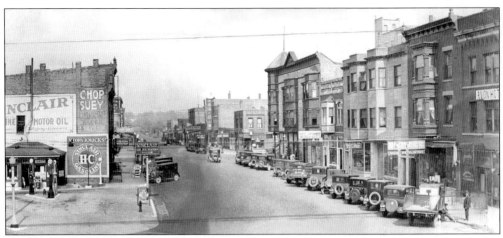

This view looks down Territorial from Water Street. The Avon Hotel and a rent-a-car facility are to the right. To the left is the Sinclair Station, a chop suey restaurant, and a dry cleaning business. (Photo courtesy of Fort Miami Heritage Society.)

Ben King presented poetry, music, and humor to large audiences throughout the Midwest. John McGovern, one of Ben King's associates said, "This young man was the drollest mimic and gentlest humorist of our region." Ben King died at the young age of 37 in 1894. In 1924, a bronze bust of the poet was dedicated in Lake Bluff Park. (Photo courtesy of the Fort Miami Heritage Society.)

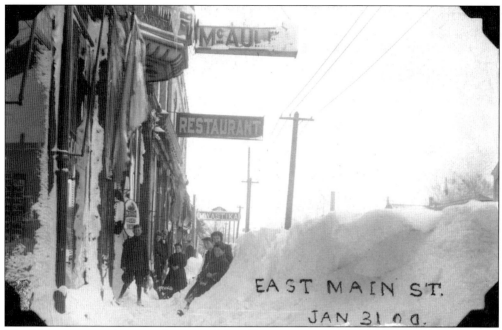
The lake sometimes brings voluminous lake-effect snow as noted in this photo on East Main Street. (Photo courtesy of Maud Preston Palenske Memorial Library, St. Joseph, Michigan.)

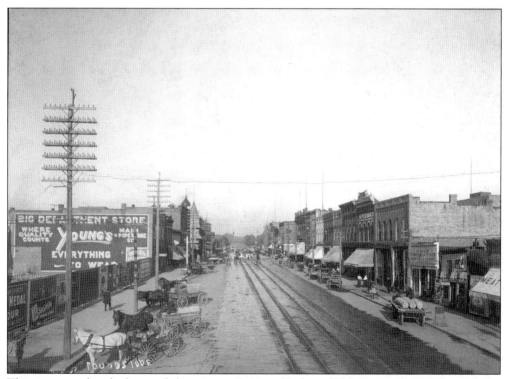
This is an undated photo of downtown Benton Harbor. (Photo courtesy of Fort Miami Heritage Society.)

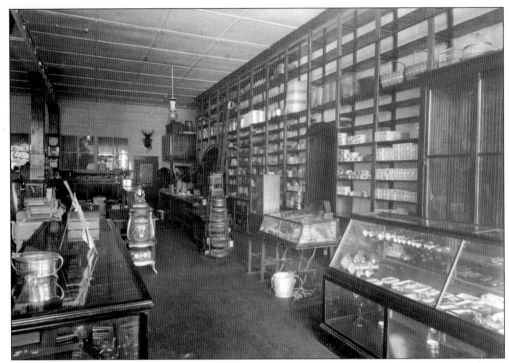

Cutter and Downing had a huge hardware and nursery store. The local family-owned farms counted on a good nursery to supply them with the plants they needed. (Photo courtesy of Fort Miami Heritage Society.)

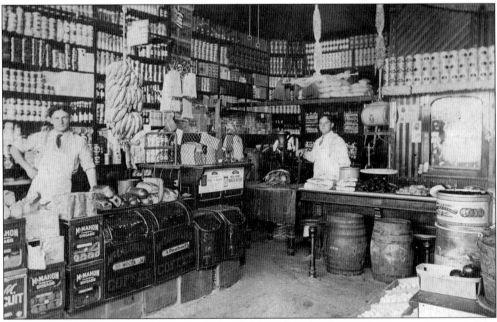

Conkey's Grocery in Benton Harbor was a gathering place for the community at the turn of the century. The community also enjoyed dances and meetings held at Conkey's Hall. (Photo courtesy of Fort Miami Heritage Society.)

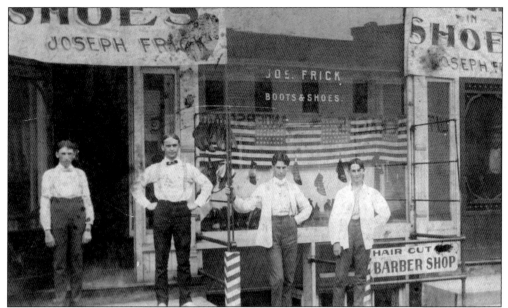

Here is Jos. Frick Boots and Shoes, with Herm Frick, Bert ?, and Tracy Clark at your service. The store operated from 1896 to 1958. The original building burned. Another seller of shoes, Will Rohn, explained, "Ladies shoes were dainty, with hand-turned soles and high laces, until 1912, when women decided to wear low shoes overnight and a whole new stock had to be purchased." Rohn said that common practice was to sell 10 to 12 pairs of shoes to a single family twice a year, spring and fall. Oftentimes, firewood was traded in on a new pair of shoes. Prior to the selling of shoes at a store, a shoemaker used to come to the home once a year to make shoes, while the settler provided the leather. (Photo courtesy of Fort Miami Heritage Society.)

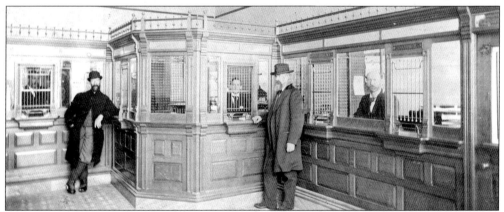

This is the Farmers and Merchants Bank in Benton Harbor. A branch of the Farmers and Mechanics Bank of Michigan, which was charted in 1834 and located in St. Joseph, was probably the first bank in the area. The next bank was the Commercial Bank of Michigan, a "wildcat" bank, which lasted only from 1837 to 1839. An explanation of this type of bank is given in the book *The Banks of St. Joseph*. Most of them used borrowed cash, as well as special certificates of worthless mortgages in place of actual capital, and immediately flooded the country with notes. Spies watched the commissioner, and money went by fast team to banks due for examination. Sometime this "capital came in the back door as the commissioner entered the front." (Photo courtesy of Fort Miami Heritage Society.)

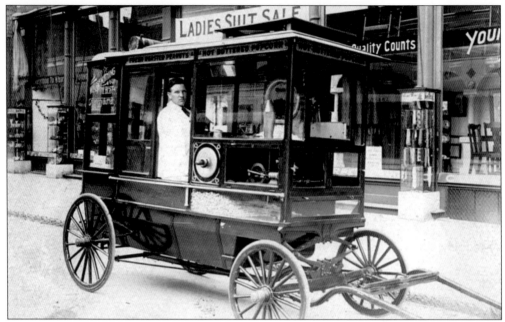

Robert H. Pritchard sold hot buttered popcorn and fresh roasted peanuts to hungry patrons in Benton Harbor. He advertised, "We're nothing but the Best" and "Creamery butter." The Young Clothing store is pictured in back. Another well-known vendor of buttery popcorn, as well as penny candy, was Popcorn John (John Moutsatson) who had a little store outside the Liberty Theater. According to Margie Souliotis he offered "the best popcorn in the world." (Photo courtesy of Benton Harbor Library.)

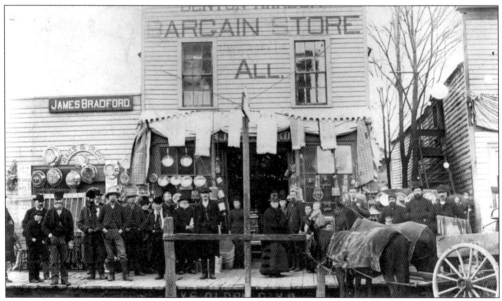

This 1892 photo of Benton Harbor shows the Benton Harbor Bargain Store with its wares artfully displayed in front of the store. To the left is the James Bradford Rags and Iron Store. Note the horse and carriage and hitching post, as well as the wooden boardwalk, which was built up to a foot above the muddy streets. (Photo courtesy of Benton Harbor Library.)

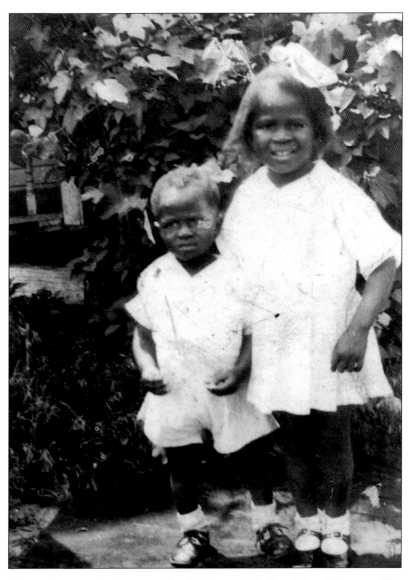

James and Gladys Peeples (pictured at ages three and four and a half) stand at the edge of "the Flats." James later became the first African-American postal clerk at the Benton Harbor Post Office. He subsequently served as Director of Finance for the City of Benton Harbor and briefly as city manager. Gladys was the first African American hired and trained as an operator in the Benton Harbor exchange of Michigan Bell Telephone Company in 1952. She earned a Ph.D. from Michigan State University and served as an administrator for the Benton Harbor School District. The Flats of Benton Harbor, where the Peeples family resided, consisted of a diverse group of people, including African Americans, Germans, Scandinavians, American Indians, and Jewish Americans. Former residents remember the closeness of the community. From the 1920s to the 1960s, the flats existed like a village within the city, with its own stores and churches and friendly neighbors. Educator Dr. Joseph Shurn says, "We really did have a village raising the children. Regardless of where you were, your behavior was monitored and there was affection displayed by all of the people you would come in contact with on a daily basis." Elaine Shoemaker, a pianist and music teacher, remembers the Flats as a place where residents lived with a sense of safety and security, when homes were generally left unlocked. She says, "Many of the children of the Flats have gone on to live accomplished lives in service to their families and their community. Theirs is a legacy of hope in the midst of hopelessness and a heritage of a multicultural community in Benton Harbor working together." Due to urban renewal in the 1960s, most of the Flats District was leveled. (Photo courtesy of Dr. Gladys Peeples-Burks.)

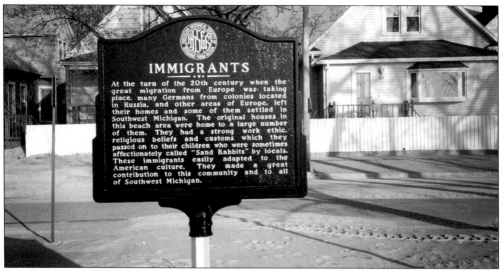

In 2002, the Southwest Michigan Chapter of Germans from Russia erected this plaque on the beach area of the Silver Beach County Park property. It was dedicated to honor the Germans from colonies located in Russia and other areas of Europe who settled in southwestern Michigan at the turn of the twentieth century. The 1920 U.S. Census shows that 80 percent of the residents of the St. Joseph beach area were of German descent. Dick Grau relates, "This is a small way in which we can acknowledge and thank our forefathers for the sacrifices made to enable us to have the good-life here in the United States." The two homes in the background, built in the first decade of the twentieth century, remain owned and occupied by descendants of these immigrants. The home to right was built in 1905, and the one behind the plaque was built c. 1910. Long considered one of the poorer areas of St. Joseph, this beach area is now undergoing an economic resurgence because it is along Lake Michigan. Many of the original houses are being demolished and large and costly homes are replacing them. (Photo by Richard Grau.)

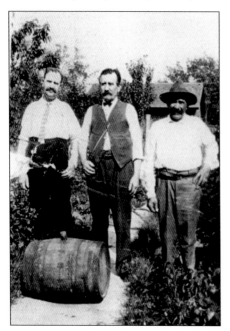

Three brothers-in-law (from left) Heinrich Neubauer, Fred Lausch, and Adam Grau, are pictured in a backyard on Pine Street (now Lions Park Drive) with a keg of beer, c. 1920. These men were German immigrants from the Province of Volynia in Russia, which today is in the northwest Ukraine. Note the vegetation in this yard area where the soil is basically beach sand. The residents used chicken and in some cases rabbit droppings as fertilizer to achieve growth in the backyard gardens that most of the residents planted. Crops raised included carrots, beets, radishes, lettuce, tomatoes, and grapes. Many of the immigrants spoke German, Russian, Polish, Ukrainian, and Yiddish. Some who were in their 60s when they immigrated here never learned to speak the English language. (Photo courtesy of Richard Grau.)

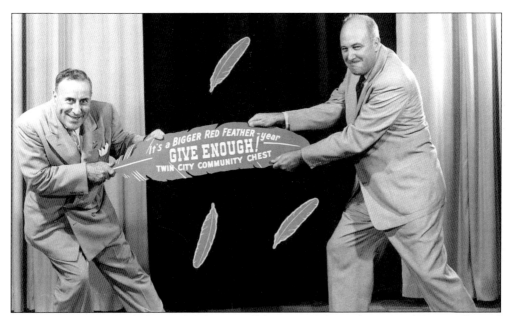

No doubt the Red Feather appeal did very well because of the enthusiasm of Ken Wallis and Howard Anthony. The Red Feather campaign for the Twin Cities Community Chest gathered money for community charities, like the Southwest Michigan Community Fund, located on State Street in Benton Harbor, does today. (Photo courtesy of Fort Miami Heritage Society.)

Dr. Harzel Taylor is a retired Benton Harbor dentist, former Benton Harbor high school star athlete and college halfback, and former secretary of the school board. This photo is from a *News-Palladium* article about a 1962 speech he gave to the Young Men's Improvement Club of Southwestern Michigan.

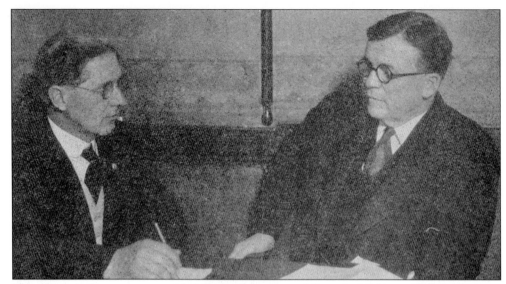

This photo is from a tract entitled *Story of Assault on Liberty in Michigan: "Red Raid" Cases.* Humphrey Gray, a Benton Harbor lawyer (at left), along with Frank P. Walsh (right), successfully defended William Z. Foster, who was apprehended and arrested at a meeting of the American Communist Party in Bridgman. Gray contributed much to the development of Benton Harbor. He was active in the Benton Harbor Development Company, which helped local businesses. He and his wife also donated a brick building, which housed the Eleanor Club, a place where working girls on a limited income could live. (Photo courtesy of Fort Miami Heritage Society.)

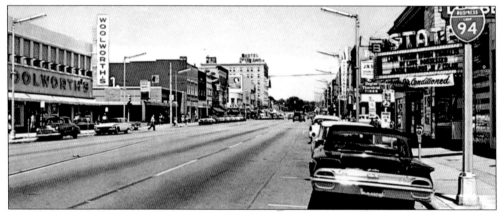

An image of State Street in the early 1960s brings back fond memories. People remember downtown Benton Harbor as a booming metropolis where people from surrounding communities, like South Haven, came to shop. Former Director of Public Safety, Sam Watson, reports, "On Fridays and Saturdays, we had to put up signs saying 'No turns' on Four Corners because of the number of pedestrians on the street." In the 1970s, things slowed down because of the loss of industry in Benton Harbor and the movement of stores to the mall. Now, however, the downtown is undergoing a transformation. The State Theater is alive and well. The Arts District thrives, and includes the studio of esteemed sculptor Richard Hunt. He remodeled a car dealership as a spacious and viewer-friendly studio and museum. Here he displays his work, African-American art, and the work of other artists, including that of resident artist, Jesus Lopez, whose work in holography has received worldwide recognition. Other artists' studios and stores are housed in quaint, renovated turn-of-the-century buildings. (Photo courtesy of Fort Miami Heritage Society.)

Sinbad's (David Adkins') appearance may have changed a lot since he was a Benton Harbor High School senior in 1974, but his intelligence, love of people, sense of humor, and youthful energy have remained constant. His parents, Rev. Donald and Louise Adkins, proudly support his career as a comedian, producer, and actor. Sinbad has appeared in numerous television shows and films, including "The New Redd Foxx Show," "A Different World," "The Sinbad Show," *The Cherokee Kid*, "The Cosby Show," "Showtime at the Apollo," and *Jingle all the Way*. Harvard University recently honored Sinbad by giving him the Artist of the Year Award, the university's highest award for performing arts. Sinbad's siblings (Mark, Michael, Donald, Dorethea, and Donna) assist him by working for his production company, David and Goliath Productions. (Photo from Benton Harbor High School yearbook.)

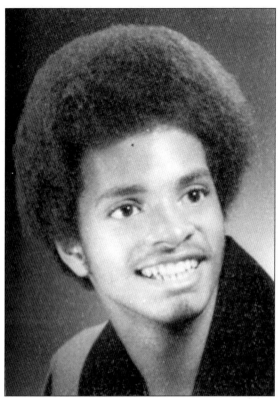

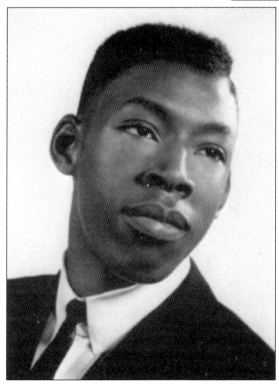

This handsome photo of actor Ernie Hudson, best known for his role as Winston Zeddmore in the "Ghostbusters" film and "Ghostbusters" music video, appears in the 1964 Benton Harbor High School yearbook. He attended Wayne State University, where he established and participated in the Actors' Ensemble Theatre, a theater group where he and African Americans directed and appeared in their own works. He also attended the Yale School of Drama and the University of Minnesota. He has acted in numerous movies, including *The Hand that Rocks the Cradle*, *The Last Siege*, and *Halfway Decent*. He has also appeared many times on television programs, including "Highcliffe Manor," "The Last Precinct," "Broken Badges," and "Oz."

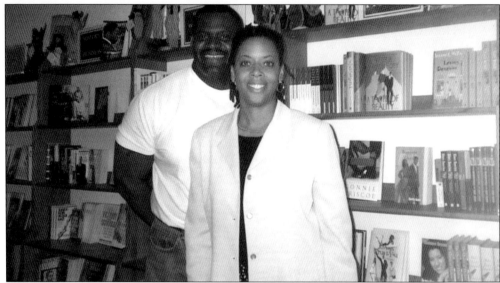

Bennie and VeLois Bowers are pictured outside their Book House Cafe and Gift Shop located in the Arts District of Benton Harbor. Bennie, who has a Master's Degree in Education, serves as a sergeant with the Michigan State Police. Bennie has developed and directed two very successful programs within the Benton Harbor community, one focusing on high school age males (Project T.R.U.T.H.) and one focusing on Junior High School girls and boys (Another Way Out). He is president of the Kappa Alpha Phi fraternity, which is building the C. Bassett Brown Youth Center. It will include a computer center, library, recreation, and training in the skilled trades. VeLois, a graduate of the University of Arkansas at Pine Bluff, is responsible for Whirlpool's Global Diversity initiative where she leads the development of global strategies worldwide. She is also responsible for providing leadership for the company's external community-based diversity and inclusion initiative, Council for World Class Communities (CWCC). (Photo by Elaine Thomopoulos.)

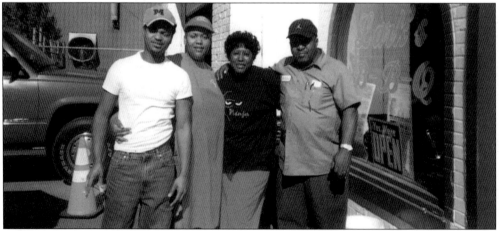

Mickey S. Stewart Sr., Willette P. Boykins, and Marilyn and Willie Lark (pictured from left to right) pose in front of Lark & Son Car Wash and Bar-B-Q at 440 W. Main in Benton Harbor. Lark graduated from Benton Harbor High School. After serving in Vietnam and working outside Benton Harbor, he returned. He started his successful business in 1996. Lark is also an assistant minister at St. Mark Baptist Church. (Photo by Elaine Thomopoulos.)

Two
COMMERCE, INDUSTRY, AGRICULTURE, AND THE BLOSSOMLAND PARADE

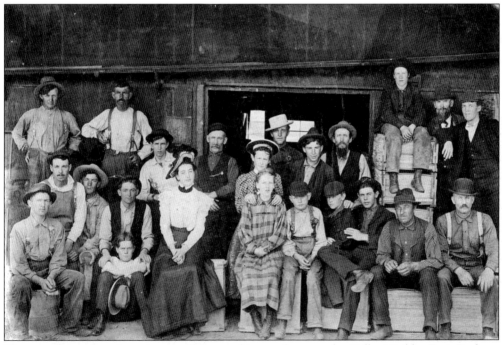

These workers take a few minutes off from making packages at the Colby-Hinkley Fruit Package Mill. Colby-Hinkley started the business in 1865 in response to the demand for cartons for the fruit industry. Note the women workers. In the early years, it was unacceptable for a single working woman to rent her own room. Some employers provided accommodations for their workers. (Photo courtesy of Fort Miami Heritage Society.)

Body language tells a lot about these company lineman, c. 1898. Note the two with their hands on their hips and the one in front holding his suspenders. The tall man on the left in the back in the only one wearing a smile. A friendly man, he rests his hands on the shoulders of the man in front of him. (Photo courtesy of Fort Miami Heritage Society.)

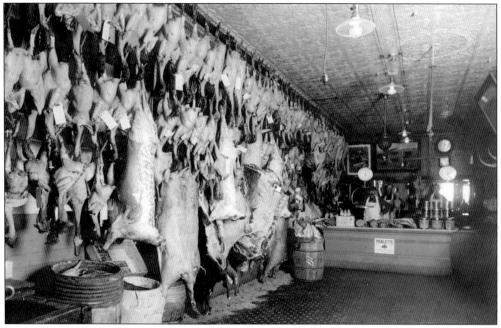

This is the Benton Harbor Meat Market of Gust Wolf c. 1904, following Wolf's purchase of the business from Charles Dunbar. No, this isn't a refrigerated unit. The meat, freshly killed, was hung like this. Another alternative was to buy the livestock directly from the farmer and slaughter it yourself. (Photo courtesy of Fort Miami Heritage Society.)

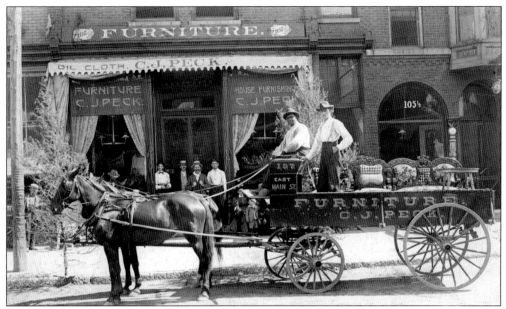

Strong men in suspenders deliver fancy furniture from C.J. Peck House Furnishings at 107 Main Street. The man to the left on the wagon is Henry Wims. (Photo courtesy of Fort Miami Heritage Society.)

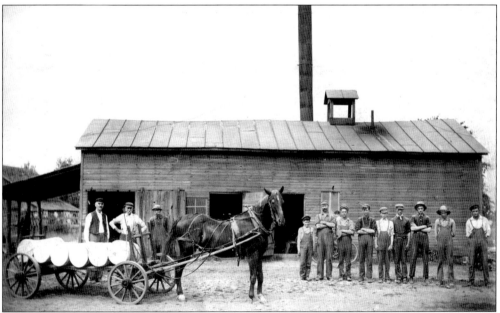

These Colby Basket factory employees take a break from their work to pose for the photographer. The basket industry developed because of the need for packages for fruit. A.E. Chauncey explains the special type of basket designed to market peaches: "The basket was small at the bottom, with a decided flare at the top. They were made in two sizes, one-fourth and one-fifth bushel. One might ask why the two sizes. It was not easy for the buyer to detect the difference in the size of the baskets, while to the grower, on a hundred baskets it meant considerable added revenue." (Photo courtesy of Fort Miami Heritage Society.)

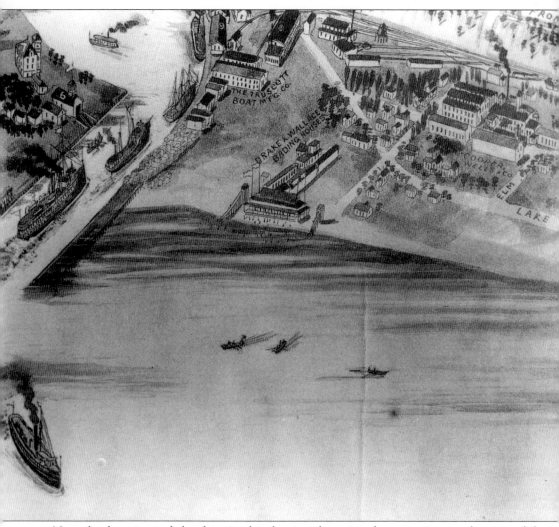

Note the factories and the ships in this drawing depicting the twin cities at the turn of the century. (Photo courtesy of Fort Miami Heritage Society.)

According to the writing on the back of this photo, the man pictured is Oscar Loesher, who mixed the dye at Cooper-Wells. Supposedly this was a secret process, which he later taught to his brother. Cooper and Sons opened their factory in St. Joseph in 1878, after their factory in Niles burned down. In 1889, the company became incorporated as Cooper-Wells Knitting Mills, with A.W. Wells as president. By 1919, they employed 517 people. Cooper-Wells made products for the war industry, but closed down in the 1950s. (Photo courtesy of Fort Miami Heritage Society.)

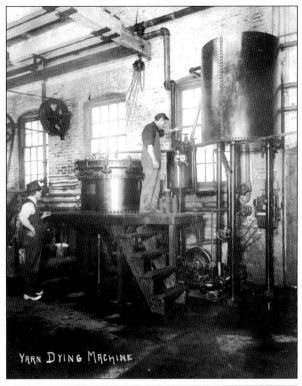

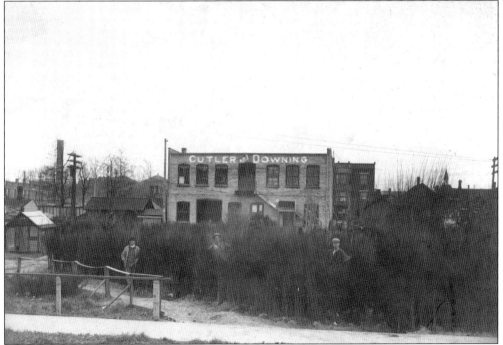

You can barely see these men outside of Cutler and Downing. This may be a nursery of Cutler and Downes. In any case, it is much like the early pioneers described Benton Harbor—a marsh with "wild rice growing as tall as a man." (Photo courtesy of Fort Miami Heritage Society.)

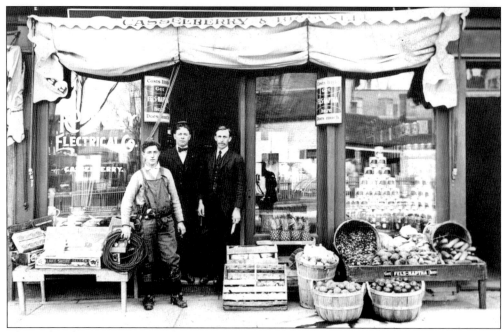

This is the electric company and grocery store. Note the bushels of produce for sale outside the store, as well as the electrician with line in hand, ready to bring electricity to store or home. Electricity in the twin cities enabled operation of the electric street cars, which served as a means of unifying the twin cities. The electric cars also traveled to outlying areas through the interurban railroad system. (Photo courtesy of Fort Miami Heritage Society.)

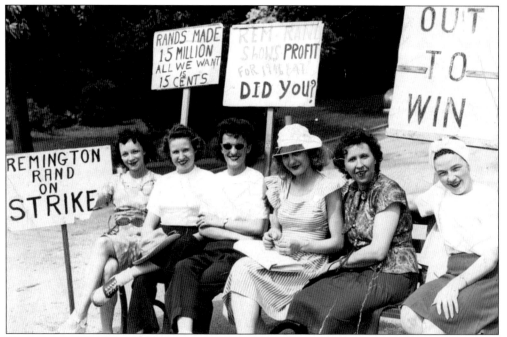

These six women strike at Remington Rand at Park and Fourth Street, Benton Harbor, c. 1948. Note the saddle shoes. (Photo courtesy of Benton Harbor Library.)

The Heath Company became famous because of its production of electronic kits designed by their engineers and shipped out world-wide. They had several facilities in Benton Harbor, and after 1952, they consolidated their operations at a new building in St. Joseph. They stopped the production of these kits in the mid-1980s. The family-like atmosphere one experienced while working for Heath is memorialized in the book by Terry Purdue, *Heath Nostalgia*. (Photo courtesy Maud Preston Palenske Memorial Library, St. Joseph, Michigan.)

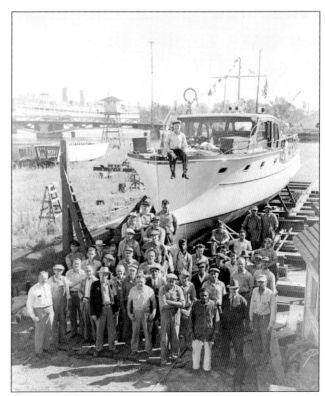

These employees of Robinson Marine have just completed the manufacture of a pleasure craft, c. 1939. They then geared up for wartime ships. During World War II, the shipbuilding industry was one of the largest employers in the twin city area. (Photo courtesy of the Fort Miami Heritage Society.)

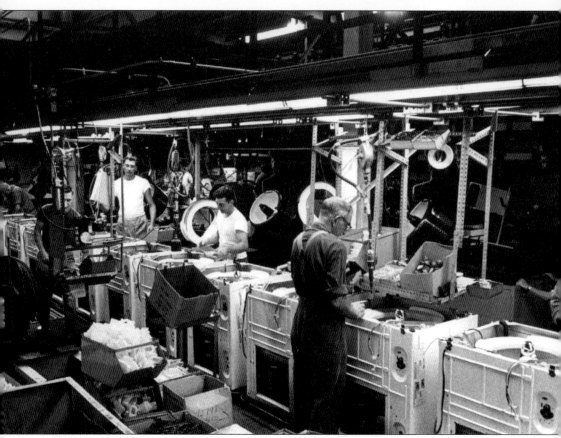
These workers are assembling Whirlpool machines. Whirlpool's headquarters is in Benton Harbor. (Photo courtesy Maud Preston Palenske Memorial Library, St. Joseph, Michigan.)

These fruit buyers, sitting quietly on the steps of the old Benton Harbor Library, could become aggressive at work. As a young child in the 1950s, Virginia Antonson remembers the buyers being right there when her aunt arrived with her peaches, berries, or cucumbers, and jumping on the truck to inspect the fruit and then start their "dickering." Antonson explains, "Sometimes if there was a glut on the market, the farmers would exchange produce. I remember her coming home with a load of watermelons." By the 1950s, the buyers dressed casually, not like these buyers of the 1920s. (Photo courtesy of Fort Miami Heritage Society.)

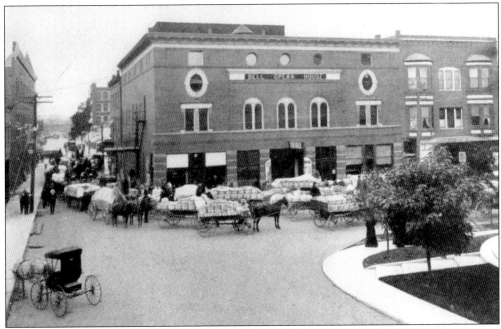

The farmers and buyers congregated at Sixth and Wells outside the Bell Opera House. Dr. John Bell, Benton Harbor's first doctor, built the Bell Opera House after the Yore burned. When he lay in state at the Opera House after his death in 1901, hundreds came to pay their respects to this beloved doctor and esteemed leader of the community. (Photo courtesy of Fort Miami Heritage Society.)

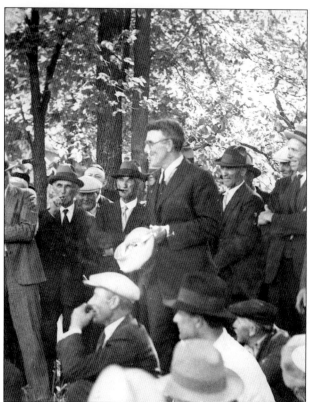

In 1930, a *News-Palladium* article reported that 200 fruit growers gathered at the corner of Fair and Highland Avenue and proposed to establish a free fruit market in competition with the new city market. The new market was located in the Benton Harbor Flats District, in the area around Ninth and Market. The fruit growers protested the municipal tax on growers and brokers. At present, the market is not owned by the city. In 1978, the growers and buyers purchased it from the city and became stockholders in the Benton Harbor Market, Inc. The market is now located at 1891 Territorial Road. (Photo courtesy of Fort Miami Heritage Society.)

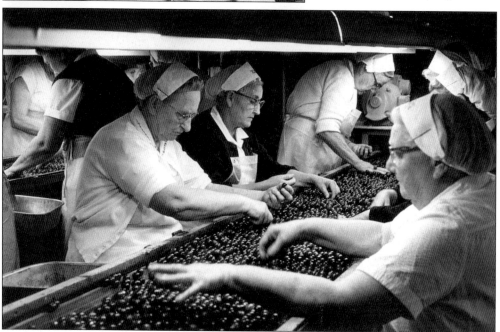

Fruit-growing in Michigan spurred other related industries. Here workers sort berries at Michigan Fruit Canners, which was established in the 1920s in Benton Harbor. (Photo courtesy Maud Preston Palenske Memorial Library, St. Joseph, Michigan.)

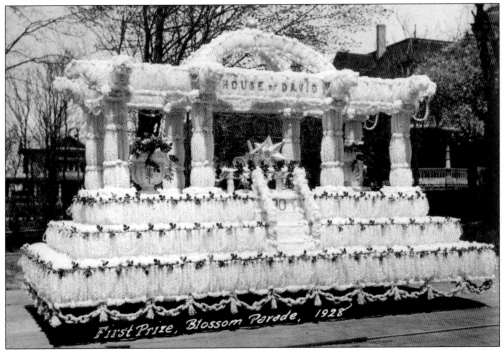

Year after year, the House of David won first prize for their Blossomtime floats. This one was featured in 1928. (Photo courtesy of Mary's City of David Museum Archive.)

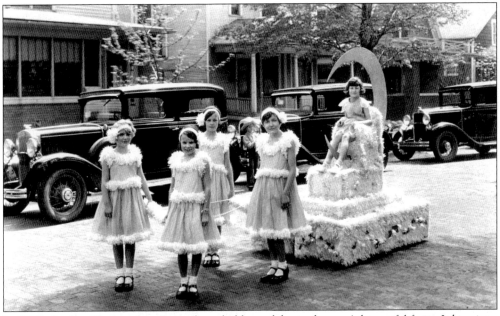

In 1923, the first Blossomtime Festival was held to celebrate the area's bountiful fruits. It has since become a major event in the community. As part of the festival, these children enjoyed the Kiddie Parade. Pictured here are Ruth Dentler, Wilma Gruner Gast, Betty Kissau Ball, Arlene Sauerbier Federighi, and Joyce Johnson Seymour. (Photo courtesy of Fort Miami Heritage Society.)

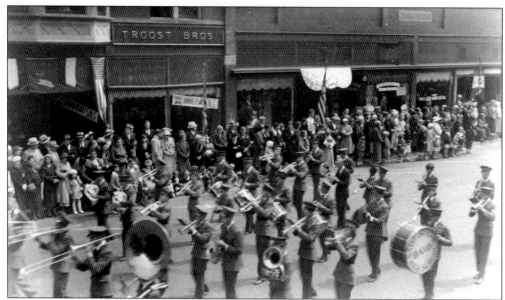

This marching band participated in the Youth Parade of the Blossomtime Festival, 1934. (Photo by Evelyn Fisher, courtesy or Maud Preston Palenske Memorial Library, St. Joseph, Michigan.)

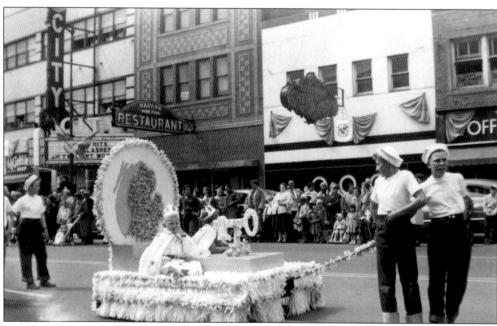

These children participated in the Youth Parade of the Blossomtime Festival in May of 1954. The Blossomtime Festival, which is traditionally on the first Saturday in May, hosts 250,000 spectators and visitors annually. The parade, which goes through Benton Harbor and St. Joseph, excites the audience with fabulous floats, high-stepping high school bands, and beautiful girls from more than 20 participating communities, one of whom will be selected Blossomtime Queen. Held to celebrate the rich bounty of the "Fruit Belt," the festival has been held continuously since 1926, except for a lapse during World War II. It was reinstated in 1952. It is the largest multi-community festival in the state of Michigan. (Photo courtesy of Benton Harbor Library.)

Three
MUNICIPAL SERVICES, HOUSES OF WORSHIP, AND ORGANIZATIONS

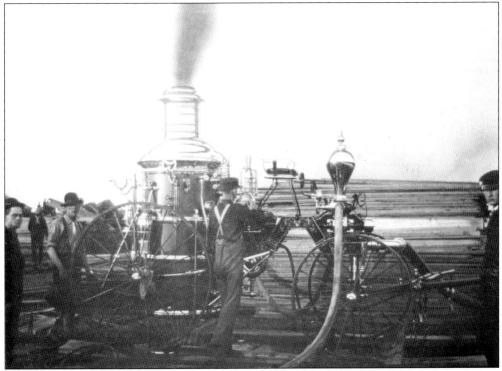

Benton Harbor's first fire department consisted of 35 volunteers and a hand-operated fire engine. In 1876, the Benton Harbor Fire Department bought a state-of-the-art $4,000 Silsby Steamer named Tom Benton (named after its inventor). The firemen fed Tom Benton wood or coal to generate steam. When the hose was put into the cistern or river, the pressure generated by the steam pumped water up and through the long hoses. In 1899, the Tom Benton was rebuilt and served the community for many years. (Photo courtesy of Fort Miami Heritage Society.)

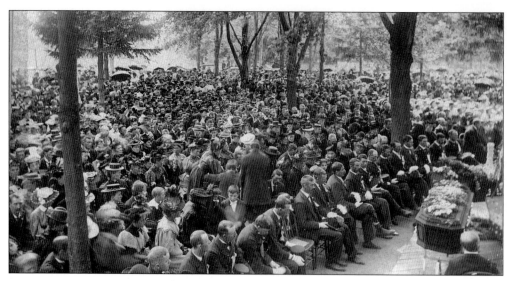

Thousands came to mourn the deaths of those who died in the Yore Opera Fire of September 6, 1896. Even though the St. Joseph firemen came to help (they lost five of their firemen), and even though Benton Harbor had modern equipment (the Tom Benton, several cisterns in town specifically to fight fires, and 1,200 feet of hose), this wasn't enough to prevent the Yore Opera House Fire from consuming the lives of 13 people. This service was held in the place between the Methodist Peace Temple and the Baptist Church. In remembrance of the firemen who lost their lives in this fire, the city of St. Joseph erected a monument, pictured below, in Lake Bluff Park. The names of the five St. Joseph firemen who lost their lives are inscribed on the monument. Benton Harbor erected a monument to their lost firefighters at the firemen's section of the Crystal Springs Cemetery. (Photos courtesy of Fort Miami Heritage Society.)

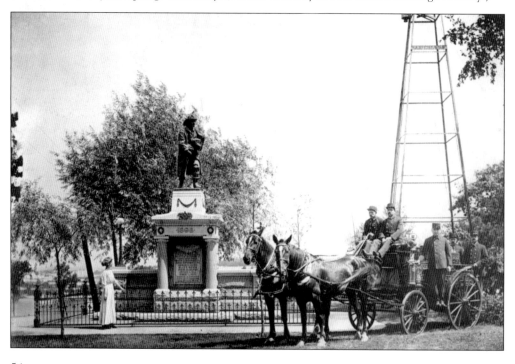

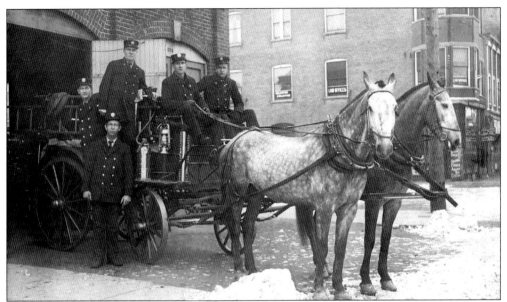

This horse-drawn firetruck is pictured at the Benton Harbor station. (Photo courtesy of Fort Miami Heritage Society.)

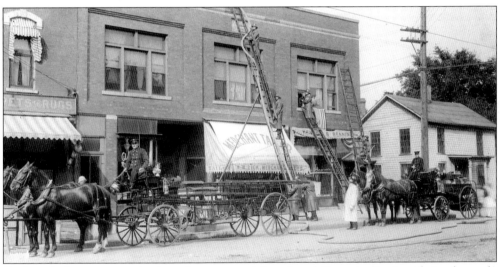

St. Joseph firemen practiced at the corner of Broad and State in St. Joseph in the early 1900s. The first St. Joseph Fire Department was organized in 1870 with volunteer firemen and with B.W. Porter as the captain. They became motorized in 1916. The firemen in the photo had progressed a lot since the early days of the department. Jeff Egillif, in his paper entitled, "History of St Joe Fire Department," relates how the volunteers would attach ropes to the hose carts and to the fire engine. "Men pulled them whenever the fire alarm sounded. Whenever they heard the alarm, the draymen would race to the fire station. Whoever got there first would hook on to the fire engine and take it to the place where the fire was. The major problem was that they could not get to the place where the fire was quickly enough. So almost all fires turned into really bad fires. The city then bought a team to haul the fire engine but the team was kept really busy working on the streets, so having the team didn't help us out a whole lot." (Photo courtesy of Fort Miami Heritage Society.)

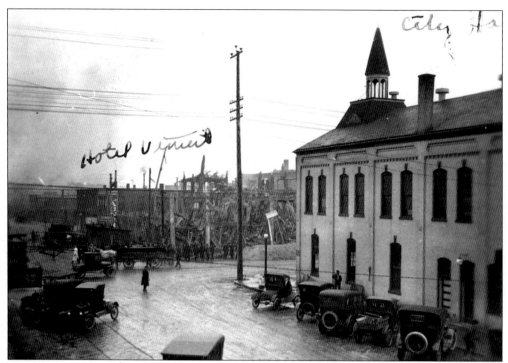

Note the collapse of the Hotel Vincent across from City Hall during construction, supposedly because the cement froze shortly after it was poured. Luckily, no one was injured. (Photo courtesy of Benton Harbor Library.)

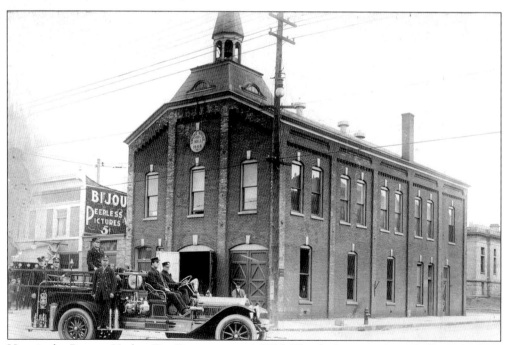

Here is the Benton Harbor Fire Department, c. 1915. The firehouse and city hall was built in 1886. (Photo courtesy of Fort Miami Heritage Society.)

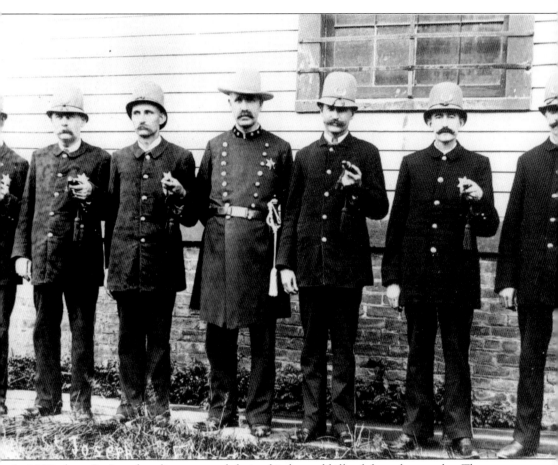

In 1898, these St. Joseph policemen used their whistles and billy clubs to keep order. They are (left to right) Henry Williams, who later became park superintendent; Phillip Russell, who became a cigar maker; O.E. Servis, candy maker and Sunday school worker; Chief Curran S. Stuckey, who first uniformed the force; William Bard; William Holland, later circuit court officer; and Abner Walker. (Photo courtesy Fort Miami Heritage Society.)

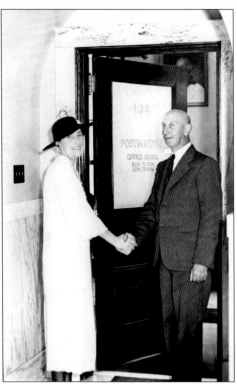

Walter Banyan turned over the job of Postmaster of Benton Harbor to Democrat Anne Parsla, c. 1933, when Franklin Delano Roosevelt became president. (Photo courtesy of Fort Miami Heritage Society.)

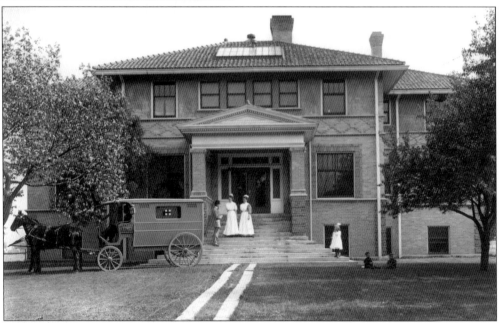

The Benton Harbor Hospital Association raised the funds to build the 24-bed hospital known as Mercy Hospital on Empire Avenue. Prior to that, Dr. Henry Tutton opened a six-bed hospital in Benton Harbor in 1899. The need for a hospital came to the community's attention after Dr. Tutton performed an emergency appendectomy on an ordinary table. (Photo courtesy of Fort Miami Heritage Society.)

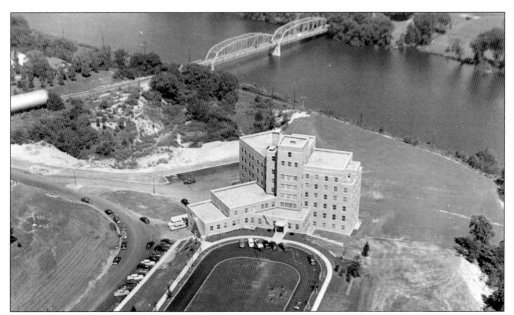

This aerial view shows Memorial Hospital in St. Joseph. More than 3,500 businesses and individuals contributed funds to establish a 101-bed hospital on the banks of the St. Joseph River in St. Joseph. They named the hospital, which opened in 1951, in honor of servicemen who died for their country. The hospital is now part of the Lakeland Regional Health System. Precursors to the hospital were the six-bed hospital established in 1899 by Dr. Henry Tutton in a two-story house in Benton Harbor, the 24-bed hospital built by the Benton Harbor Hospital Association in 1907 known as Mercy Hospital, and the house that Dr. Theron Yeoman remodeled on Niles Avenue in St. Joseph in 1915 to create the six-room St. Joseph Sanitarium. (Photo courtesy of Fort Miami Heritage Society.)

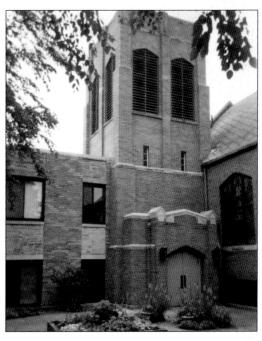

Swedish immigrants formed the Saron Lutheran Church in 1875. Typical of immigrant churches, services were conducted in the native language until the 1930s, when they switched to all-English services. In 1882, the church held services in Barlow Hall, formerly a roller rink. They broke ground for their building on Main Street in 1927. In 1950, they added the Sunday school and offices. (Photo by Elaine Thompoulos.)

LAYING OF CORNER STONE.
ICE-CREAM & PEACH FESTIVAL!

The Corner Stone of the New M. E. Church, of this place, will be laid with appropriate ceremonies, on

FRIDAY, AUGUST 31, 1866,

At 4 O'clock P. M.

REV. H. CREWS,

Of Chicago, will deliver the address on the occasion.

AN ICE-CREAM AND PEACH FESTIVAL for the benefit of the Church, will be given in the Perkins House Hall, in the evening. The public are cordially invited.

BY ORDER OF COMMITTEE

On August 31, 1866, the laying of the corner stone of the Methodist Episcopal Church at Main and Broad (southeast corner) was celebrated by a ceremony followed by an ice-cream and peach festival. The Rev. H. Crews served as pastor. (Photo courtesy of Fort Miami Heritage Society.)

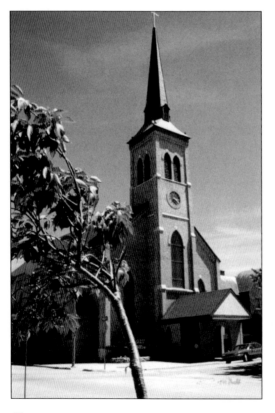

In 1849, the Catholic community in the St. Joseph and Benton Harbor community consisted of six families. It had no resident priests and remained a mission until Rev. Joseph Van Waterschoot came in 1865. Seven years later the congregation built a brick church, St. Joseph's. Father James Gore became pastor of the parish in 1890 and remained in that position for about ten years. While he was there, St. Anthony's chapel was built and the steeple was placed on the church. The church clock placed in the steeple is probably the first public clock in Berrien County. The present school, supported by the parish, began in 1909, and continues serving the community. In 1929, the high school began, and in 1933 it graduated 18 students. (Photo by Pat Moody of Cornerstone Chamber of Commerce.)

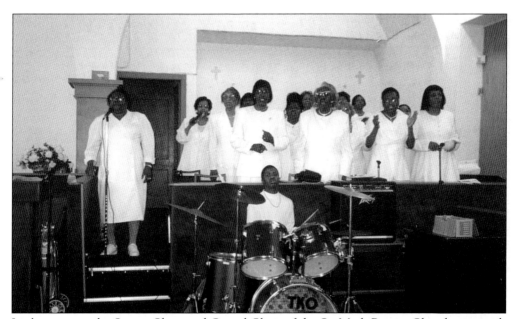

In this picture, the Senior Choir and Gospel Choir of the St. Mark Baptist Church sing, with Rosetta Austin as soloist and James Cumming at the drums. Rose Coleman Washington is choir director, and the pastor of the church is John L. Price. (Photo by Marilyn Lark.)

This is St. Mark's Baptist Church at Clay and Pavonne in Benton Harbor. It originally was the First German Baptist Church. The origins of the First German Baptist Church began with the arrival of four immigrant families who had left Prussia to escape religious persecution. They lived together in one house, and their pastor, W.E. Grimm, held services every Sunday. They built their first church at the corner of Church and Broad Streets in 1856 and later built another church on the corner of Clay and Pavonne; in 1958, they moved into a new and larger church and changed their name to Napier Parkview Baptist Church. The German Sunday School class of Napier Parkview decided to organize another church, wanting to hold services in the English language. They purchased the old Clay Street property and named it First German Baptist Church. They held their first service in 1958. In 1971, the old church building on Clay Street was sold to St. Mark's Baptist. The new church built by the congregation of First German Baptist Church is known as the Oakridge Baptist Church. Today, the church services are in English, with a German-speaking Sunday School for the now elderly immigrants who came to the United States after World War II. (Photo by Elaine Thomopoulos.)

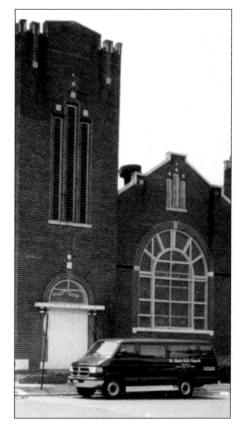

The Daughters of Penelope (pictured here) is the women's auxiliary of the American Hellenic Educational Progressive Association (AHEPA), a national fraternal organization. Beginning in the 1930s, the Daughters of Penelope, together with the AHEPA, raised funds for the Annunciation Greek Orthodox Church through annual summer picnics. Thousands of non-Greeks enjoyed the delicious Greek chicken, baklava, and lively Greek music and dancing at these picnics. Built at 725 Broadway in 1949, the church was sold and later relocated to New Buffalo under the name Annunciation and Saint Paraskevi Church. (Photo courtesy of the Annunciation and St. Paraskevi Greek Orthodox Church.)

Greek immigrants built the Annunciation Greek Orthodox Church at 725 Broadway in Benton Harbor in 1949. Because the immigrants wanted their children not only to retain their Greek Orthodox faith, but also the Greek language, history, and traditions, they started a Greek school, which met after school or on Saturdays. On religious and Greek holidays, the children recited Greek poems and songs. The holidays included Greek Independence Day (celebrating Greece's independence from the Ottoman Empire in 1821 after 400 years of domination) and Ohi Day, when the Greeks said "Ohi" ("No") to Benito Mussolini's demand to surrender during World War II. Here, in 1972, the children recite poems in the church hall, under the direction of Rev. Christos Moulas, who retired in 1982. The programs were always followed by a delicious meal of homemade Greek food. (Photo by Mike Kerhoulas.)

This is St. Peter's Evangelical Lutheran Church confirmation class, c. 1913. The photo was taken by R.G. Smith of St. Joseph, Michigan. (Photo courtesy of Fort Miami Heritage Society.)

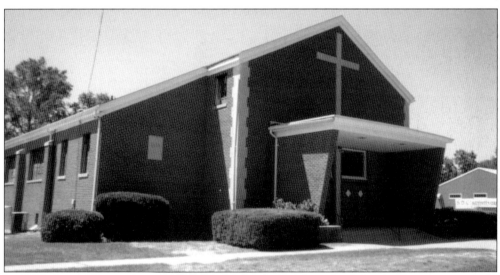

In 1875, Second Baptist began as an outgrowth of a Sunday school that held its meeting at 84 Main Street, above the Five and Ten Cent Store. In 1880, Rev. Cromwell organized a church on Bronson Street. After this church burned, it reorganized on Colfax and moved to Eighth Street, then in 1956 to 477 Cherry Street, and finally in 1974 to 600 Donald Adkins Drive, the former Benton Harbor Tabernacle. Rev. Donald B. Adkins, a native of Benton Harbor, served as pastor from 1966 to 2000 and continues his service as pastor emeritus. Morris Gavin currently serves as pastor. In 2002, the church completed construction on a 45-unit Senior Citizen Housing Complex on Donald Adkins Drive and also has added an activities center called Sinbad's Imagynasium, where there are computers and a gymnasium. (Photo by Elaine Thomopoulos.)

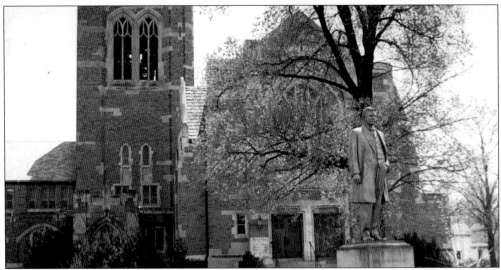

The Congregational Church of Benton Harbor, probably the first church in Benton Harbor, was organized in the 1860s by those who had left the St. Joseph Church. They built the first church, a wooden structure, on East Main. In 1890, a brick church was built at Broadway, Bellview, and Pipestone, with J.N. Klock as chairman of the building committee. It burned in 1926, and the present church was dedicated in 1928. This church, as well as others in the area, actively get involved in community-wide endeavors. In 2002, First Congregational Church UCC of Benton Harbor, Progressive Missionary Baptist Church, Calvin Britain Elementary School, Benton Harbor High School, Curious Kids Museum and Krasl Art Center collaborated on a summer program for Benton Harbor Elementary School that combined education with recreation. The statue of Theodore Roosevelt shown in the foreground of the photo was donated by the Federation of Women's Clubs. (Photo courtesy of Benton Harbor Library.)

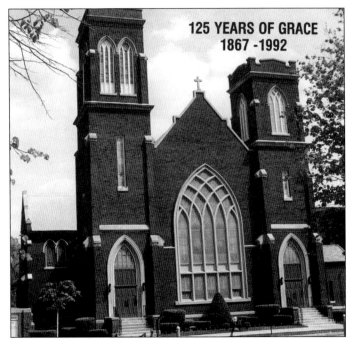

This photo, from the *125th Anniversary Book*, shows Trinity Lutheran Church, located at 715 Market in St. Joseph. The church was established in 1867 as the German Evangelical Lutheran Trinity Church on the east side of the 600 block of Court Street. The building was used for the church as well as its first school. In the early years, men used to sit on one side and the women on the other. In 1886, there was a second church built on the corner to the south. The church pictured, the third church, was built in 1925.

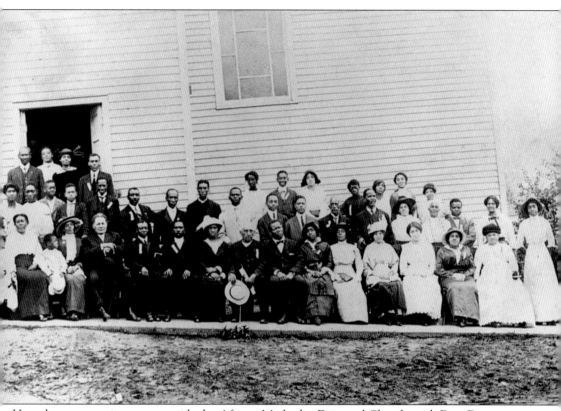

Here the congregation poses outside the African Methodist Episcopal Church, with Rev. Dean as pastor. According to an article in the *News-Palladium* (March 17, 1950) the Union Memorial African Methodist Episcopal Church started in 1868 in the home of Henry Wims of Benton Harbor. L. Benj. Reber reports that Rev. W.T. Langford organized the African Methodist Episcopal Church in St. Joseph in 1871. According to Rev. Langford, charter members included Steve Busby and his wife, John Hart, Bob Cross, Mead Miller, Huston, Lounge, and Sharp. In the 1920s, the congregation built a church on Colfax Avenue and Bond Streets in the Flats of Benton Harbor. It is now located on 911 S. Crystal Avenue in Benton Harbor. Henry Wims, in whose home the church first met, was born into slavery in Kentucky, one of 18 children, according to a 1921 newspaper article. Without any formal education, Wims built a flourishing dray and taxi business, as well as an electrical rug cleaning business. He had a contract to clean the rugs for the Graham and Morton boats. The reporter writes, "Mr. Wims . . . is one of the best known and liked men in town for his honesty, sincerity and kindly manners." (Photo courtesy of Benton Harbor Library.)

Next page: The top photo, c. 1912, is from the *Temple B'nai Shalom Centennial Anniversary Book*, printed in 1925, and shows the Baby Dolls, a girls' social club from the Children of Israel Synagogue. The Children of Israel, an Orthodox synagogue, incorporated in 1895, according to a history written by Michael Eliasohn and an interview with Seymour Zaban. The charter was issued in 1900, and the first synagogue was built on Eighth Street in the Flats. The bottom photo on the next page was taken inside. Having outgrown the original structure, a new Children of Israel Synagogue was built in 1925 at 114 Lake Street. A second Orthodox synagogue, Ohava Sholom, was formed in 1911. Members constructed a building at Seeley Street and Highland Avenue, near Jewish resorts and Jewish-owned farms. In 1959, the two congregations merged to form B'nai Sholom, a conservative synagogue, and moved to their new building at the corner of Broadway and Delaware Streets in Benton

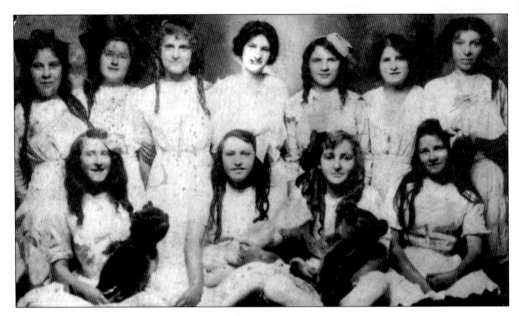

Township in 1963. A few residents of the Benton Harbor-St. Joseph area formed Temple Beth-El in 1934, "dedicated to a liberal interpretation of Judaism." World War II delayed the construction of the synagogue until 1949. By 1959, membership had grown to 101 families. Temple Beth-El merged with B'nai Sholom in 1971 under the name Temple B'nai Shalom, using a modernized spelling of the Hebrew word for peace. From the 1930s to the 1970s, Jewish vacationers at Mary's City of David worshipped at the synagogue constructed on the grounds of the resort. Many of the Jewish immigrants came from poor farm villages in Russia at the turn of the century. Some established farms on the fringes of Benton Harbor and others became merchants. Many of the farmers struggled to make a living and formed the Berrien County Jewish Farmers' Association, which consisted of about 50 families, to help each other. Many of the children of the immigrants, after receiving a college education, left the area for opportunities in larger cities like Chicago. They brought with them the values of faith and family that they learned from their parents.

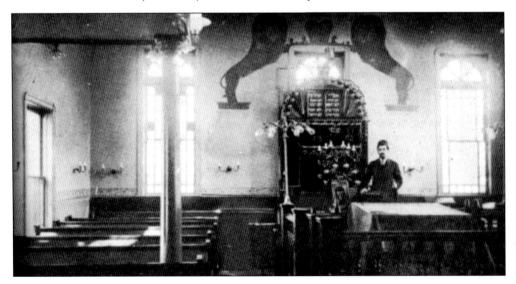

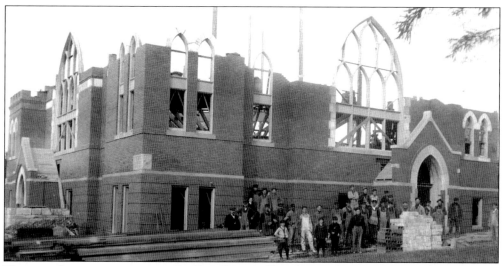

These workers are constructing the First Baptist Church at 245 Pipestone in Benton Harbor. The First Baptist Church of Benton Harbor was organized in 1863 with a congregation of 28 members. By 1865, they built a chapel at Heath's Corner, and in 1869 they broke ground for a brick building at 245 Pipestone. When a fire destroyed the church structure, they rebuilt the beautiful brick building pictured in this photo in 1910. The building is now home to the Progressive Missionary Baptist Church, with Reverend James O. Childs as pastor. (Photo courtesy of Fort Miami Heritage Society.)

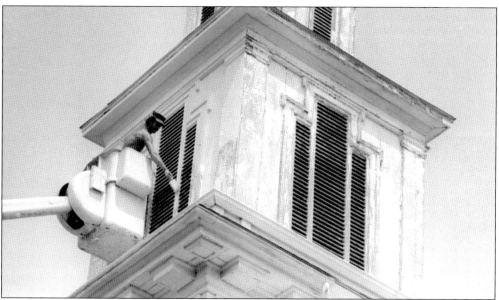

Wayne Hamilton precariously paints the former St. Joseph Congregational Church in 1989. This was Fort Miami Heritage Society's site from 1989 until it burned down in 1994. Dedicated volunteers salvaged much of the photographic and archival collections from the water-logged building. Wise conservation measures preserved them. Fort Miami built a beautiful new building at the same site in 1998, where it displays exhibits regarding the area's history, maintains archival collections, and has a hall and meeting rooms for community functions. (Photo courtesy of Fort Miami Heritage Society.)

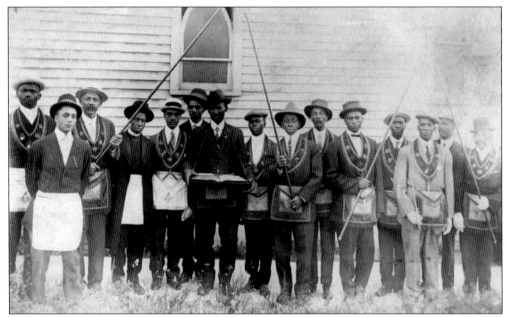

This photo of the Masons (Harbor Lodge 15) was taken at the African Methodist Episcopal Church. The writing on the back photo indicates: "Far right back row George Hackley, third from right back Boon, next Mr. Dusam, Mr. Rider, Rev Dean's son, Arthur, eighth from right Chas. Holland, fifth from left Wm. Wims, first on ? Mr. Redfern." (Photo courtesy of Benton Harbor Library.)

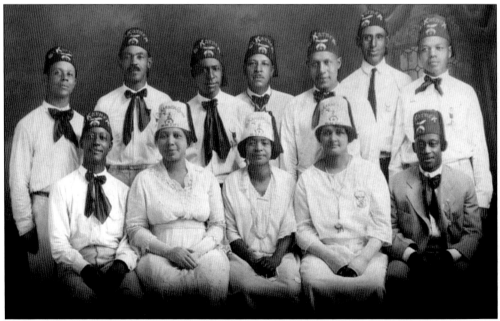

Here is another photo of the Masons, but it also includes the Eastern Stars. According to notes found with the photo, third from left in back is Elisha Boone, George Varouthers is second from left back, and Minne Crouthers, second from right in the front row. (Photo courtesy of Benton Harbor Library.)

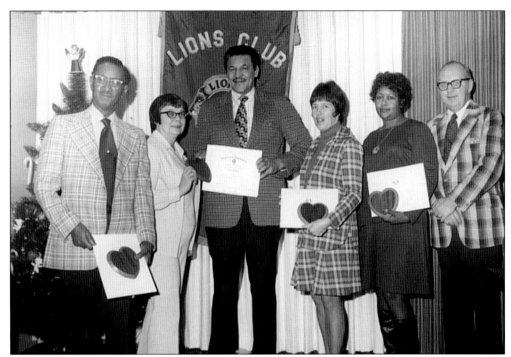
This is a presentation of the Lion's Heart Awards to those who have given outstanding service to the community. Roy Shoemaker, past president of the Lions Club, is standing in the middle. The Lions Club participates in various philanthropic activities, including providing services to the blind. (Photo courtesy of Roy Shoemaker.)

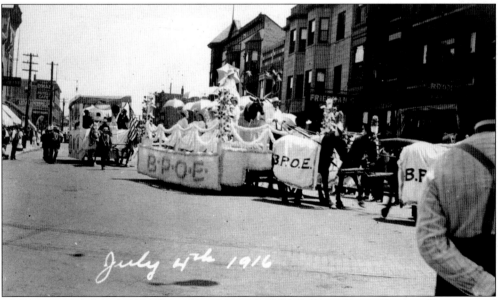
The men's clubs, including the BPOE, Masons, Odd Fellows, Lions, Rotary, Kiwanis, and various veterans' organizations, contributed to the development of the twin cities. They got involved in charitable and civic activities and continue to do so today. Here we see the BPOE float at the July Fourth parade in 1916. (Photo courtesy of Benton Harbor Library.)

The ladies of the Antiquarian Society pictured in this photograph are (left to right): Mrs. Coolidge, unidentified, Mrs. Eldon Butzbaugh, Mrs. Frederick S. Upton, and Mrs. Hatch. Mrs. Roy Moulton and Mrs. Robert Evans founded the Antiquarian Society in 1929. There were 26 members, with J. Stanley Morton as the only honorary male member. (Photo courtesy of Fort Miami Heritage Society.)

Rich Ray and Rich Hensel, owners of Global Greenery in the refurbished Hinkley Building on Water Street, hold up a sign they salvaged from the Benton Harbor Lodge of the International Order of Odd Fellows (IOOF). It lists the names of the organizations that met there many decades ago: Lake View Encampment No. 37, Marquette Rebekah Lodge, WBA No. 35, DUV Tent No. 34, Royal Neighbors, Canton No. 55, GAR Ladies, and WBA No. 71. (Photo by Elaine Thomopoulos.)

This newspaper clipping shows the women of the Ossoli Club. In 1894, seven women met at the home of A.K. Farmer in Benton Harbor to form the club. Sara Fuller, who had just graduated from college, named the club the Ossoli after she became inspired by the brilliance and energy of Margaret Fuller Ossoli, an author, activist, and "citizen of the world" who died at a young age, along with her husband and child, when the ship they were taking to the United States from Europe sank. The club supported women's rights, even back in the days before suffrage for women, and featured art, poetry, music, history, books, and drama. By 1909, there were 92 members. Women's clubs have been very active in the St. Joseph and Benton Harbor area and have contributed tremendously to its cultural and social welfare programs. Another group that took their inspiration from an author and also featured literary readings, poetry, music, and drama was the Phyllis Wheatley Women's Circle, a Benton Harbor African-American women's group. The Phyllis Wheatley Women's Circle also included Henrietta Stone, Carrie Busby, Frances Worix, Doris Kelly, Ella Newland, and Grace Busby. An article in the June 6, 1901 *Daily Palladium* reported that 85 people came for a banquet where Misses Mildred Brown and Eva Stone presented a description of the life of Phyllis Wheatley. The famous poet, born in West Africa, was kidnapped and brought to New England in 1761, when she was six or seven years old. A wealthy merchant bought her to serve his wife. They treated her more like a member of the family than a slave. Recognizing her intelligence, they educated her in religion and the Classics. She gained national and international recognition for her poetry. Wheatley was freed from slavery in 1774, and in 1778 she married a free black man who eventually abandoned her and their three children. Two of her children died, and she herself died at the age of 31. Her third child died within a few hours of Wheatley and was buried with her in an unmarked grave.

In 1967, the Alumnae Chapter of the Delta Sigma Theta Sorority established its Benton Harbor-St. Joseph chapter. This is a recent photo. Pictured from left to right (front row): Gladys Peeples-Burks, Betty Colombel, Alice Shurn, Kathleen Joyner, Dorothy Parker, Lisa Peeples-Hurst, VeLois Bowers, Lesten Alston, Joyce Butler, and Mary Newcomb Ealy; (second row) Debra Stigall, Mary Meeks, Dorothy Moon, Ganella Anderson, Barbara Peeples, Jacinda Lowery, Patricia Brown-May, Glenda Gibbs, Anita Burton, Brenda Terrell, Disa Kenney, Lois Peeples, Itiernajerha Oghoghomeh, Merna Llorens, Charlene Brooks, Karen Banks, Sheryl Finley, and Jean Sanders. Other African American Greek letter organizations in the area with active chapters include Alpha Kappa Alpha Sorority and Kappa Alpha Psi Fraternity. (Photo courtesy of Barbara Peeples.)

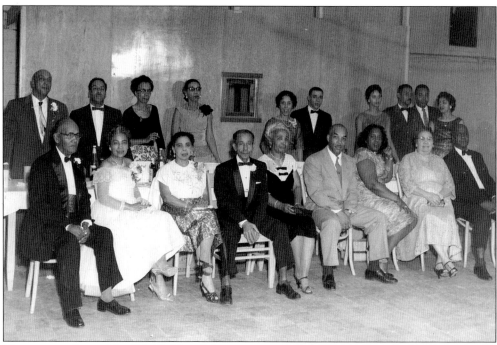

Here are members of the "18 Club" and their guests, celebrating their annual party, c. 1952. The club, which was started in the 1930s, continues today with 18 members. They get together to enjoy each other's company and to share old stories. (Photo courtesy of William Seabolt.)

Four
EDUCATION, CULTURE, AND THE ARTS

Professor George Edgcumbe, Ph.D., is pictured with his wife and children, c. 1897. Professor Edgcumbe and community leader Seely McCord founded Benton Harbor College, a college preparatory and normal school in Benton Harbor. A native of England, Edgcumbe came to Michigan from Canada and served as Superintendent of Public Schools in Benton Harbor prior to starting the college in 1886. His wife was responsible for the elementary and preparatory programs. Both of them were well-liked and respected. The college employed from 17 to 20 teachers and was ranked amongst the best in the state. A few years after his death, the college ceased operating. (Photo courtesy of Fort Miami Heritage Society.)

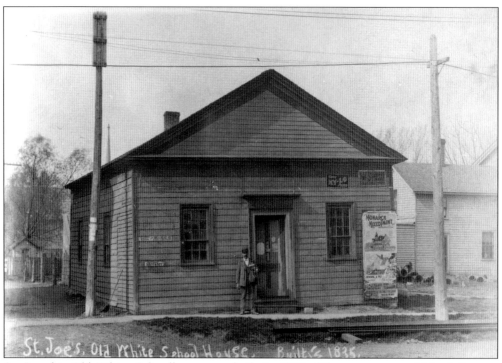

St. Joseph's Old White Schoolhouse was built in 1835. (Photo courtesy of Maud Preston Palenske Memorial Library, St. Joseph, Michigan.)

This is a photo of the Garfield fifth grade class. (Photo courtesy of Fort Miami Heritage Society.)

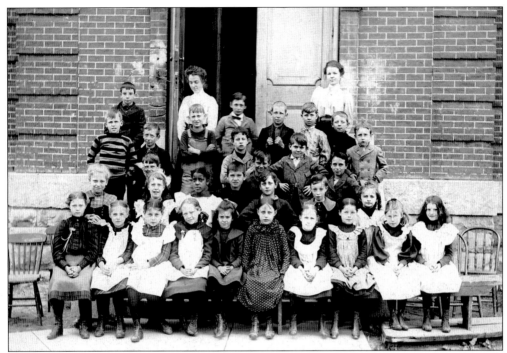

The teachers of this 1900 third grade class at Washington School are Cora King (left), sister of the poet Ben King, and Miss Blackmun. For a while, Washington School was the only school in St. Joseph, serving students in the elementary and high school grades. (Photo courtesy of Fort Miami Heritage Society.)

The patrol boys at Washington School c. 1949 took their jobs very seriously. (Photo courtesy of Maud Preston Palenske Memorial Library, St. Joseph, Michigan.)

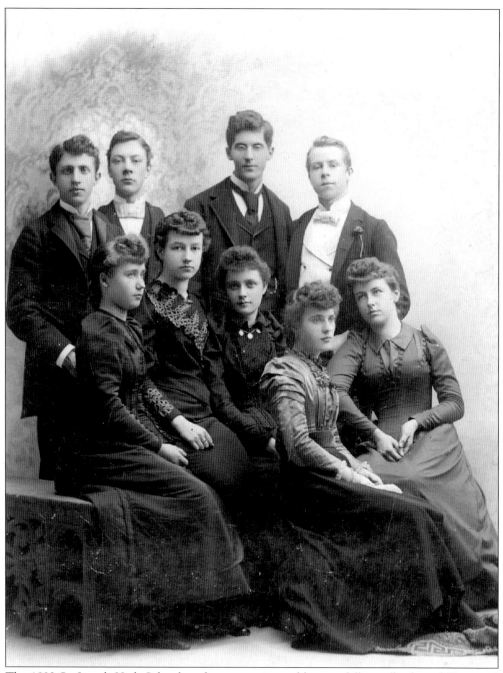

The 1892 St. Joseph High School graduates are pictured here as follows: (back row) Raymond Donaldson, Elmer Barnes, ? Wilson, and Roy Moulton; (front row) Dora Foltz, Alice Helmer, Maggie Wilkinson, and Flora Greening. One of the young ladies in the front row is unidentified. (Photo courtesy of Maud Preston Palenske Memorial Library, St. Joseph, Michigan.)

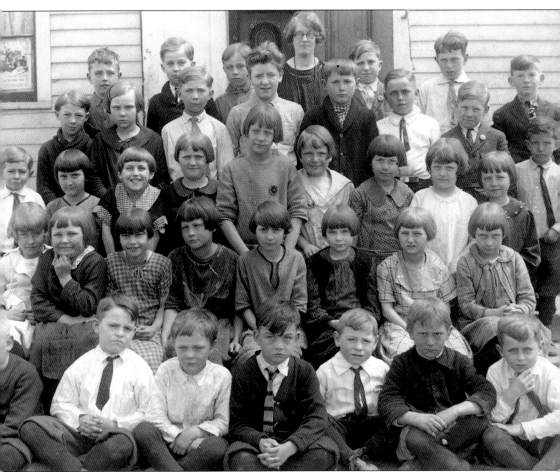

In this photo of a North Lincoln School class, c. 1925, there is a sign in the window saying "Health for You," with what looks like a knight slaying a dragon. Schools taught reading, writing, and arithmetic, but health was also important. Karla Lieberman, in her booklet, *North Lincoln School, 1860–1983*, writes that the school was originally a one-room school needed for the children of the immigrants from Germany and Poland who settled in this area. She explains, "The property for the new school was donated with the stipulation that the building be constructed with double doors. This was requested so that funerals for the deceased from this area could be conducted nearby. Approximately in 1893, the one room wood frame structure, with a wood shed, was built. A fence was put up around the schoolyard to keep the neighboring farmers' cars out. In 1905 another room was added to the north side of the building. A basement was put under this room and a furnace was installed. The large room was used for grades 5–8 and the small room was used for grades 1–4 In 1953–1954 a new four room brick school was completed." Lieberman continues, "The name North Lincoln will recall memories of laughter, sadness, friends and the hard work of getting an education to anyone and everyone who has been affiliated with the schools…From 1860 to 1958 approximately 3,500 students attended the log school house and the white frame school building. From 1959 to 1983, 8,830 students have traveled the halls and filled the classrooms of North Lincoln School. The school may be closing but the memories will remain with us forever." (Photo courtesy Fort Miami Heritage Society.)

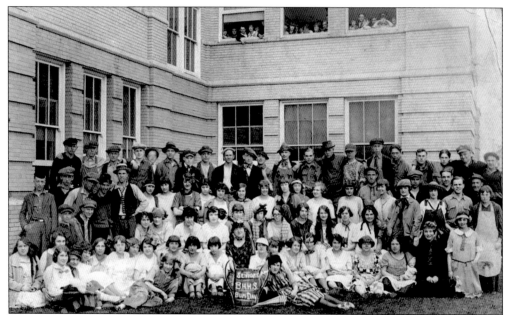

The sign in the middle of the photo notes "Senior BHHS Bum Day." Even though these young people are dressed like "bums," aren't they adorable? Note the younger students looking out of the windows, waiting for the day when they too will be seniors. Many of the students at the Benton Harbor High School came from farms. As late as 1940, according to a report issued by St. Joseph and Benton Harbor, 40 percent of the students came from the rural areas. Even city kids worked on the farms during the summers, picking fruit in order to have enough money for school, clothes, and supplies. (Photo courtesy of Benton Harbor Library.)

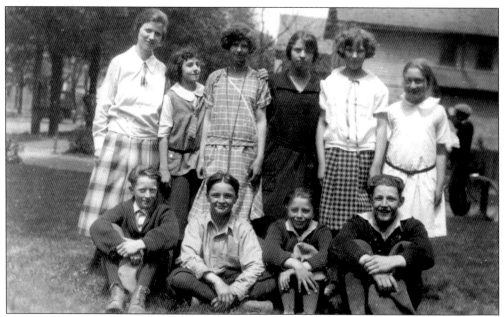

Sarah Smart, teacher, poses with the students of the junior high on Broadway in 1924. (Photo courtesy of Benton Harbor Library.)

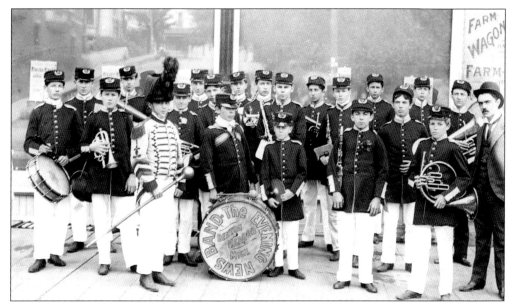

These boys played in the Evening News Newsboys' Band. J.N. Klock was the editor and proprietor of the newspaper and supporter of the band. Klock became known in the community not only as an astute businessman (he was president of Malleable Industries), but also a philanthropist. He and his wife donated the land for the Jean Klock Park on the shores of Lake Michigan in memory of their young daughter. (Photo courtesy of Fort Miami Heritage Society.)

The Benton Harbor High School Band marches in a parade. Music has always been an important part of local life. There are also concerts and performances offered at the parks of Benton Harbor and St. Joseph on a regular basis, with a variety of music, from classical to jazz and rhythm and blues. Other musical endeavors include the Monday Musical Club, organized by women in the area in 1908. It offers scholarships to music students and presents an annual Christmas Vespers Program. (Photo by Pat Moody of the Cornerstone Chamber of Commerce.)

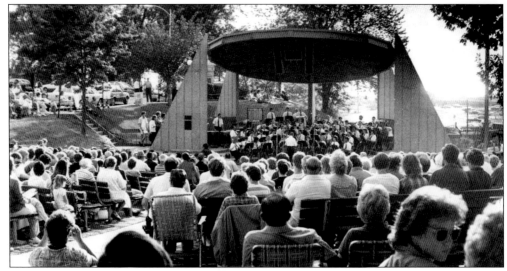

The St. Joseph Municipal Band has entertained area residents since 1938. They perform regularly at the John E.N. Howard Band Shell in St. Joseph. Berrien County audiences also enjoy the Southwestern Michigan Orchestra (previously known as the Twin Cities Orchestra), which regularly plays at the Mendel Center of Lake Michigan College and other venues. Another organization that brings culture to the area is the Twin City Players, a theater group founded in 1932. (Photo courtesy of Fort Miami Heritage Society.)

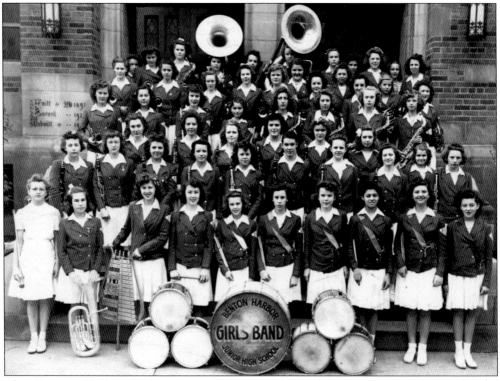

The Benton Harbor Girls Junior High School Band 1942–1943 pose outside the Congregational Church. (Photo courtesy of Benton Harbor Library.)

Mayor Charles Yarbrough welcomes Herbert D. Mendel at the dedication of the Herbert D. Mendel Arts and Commerce Building in downtown Benton Harbor. The Mendels also provided funds for the construction of the Mendel Center at Lake Michigan College in Benton Harbor. (Photo by Pat Moody of the Cornerstone Chamber of Commerce.)

Niki Harris sings at a Benton Harbor concert in memory of her father, the famous Jazz musician from Benton Harbor, Gene Harris. Niki is an actor and choreographer, as well as a well-known singer. Her father, Gene Harris, teamed up with another famous Benton Harbor musician, Bill Dowdy, in the 1950s and 1960s. They performed as the Four Sounds, later pared down to the Three Sounds. Gene's career spanned a half-century. A man of much energy, Harris delighted in performing to audiences around the world, including in Japan, Australia, and Europe. He last performed in Hawaii in October of 1999. He died on January 16, 2000. (Photo by Pat Moody of the Cornerstone Chamber of Commerce.)

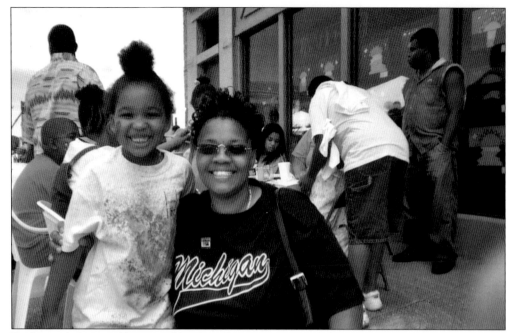

Bridgette A. Ison and her granddaughter Brianna Ison enjoy the Benton Harbor Children's Art Fair, which has been held in Benton Harbor each summer since 1997. At the fair, Brianna designed the t-shirt she is wearing. (Photo by Elaine Thomopoulos.)

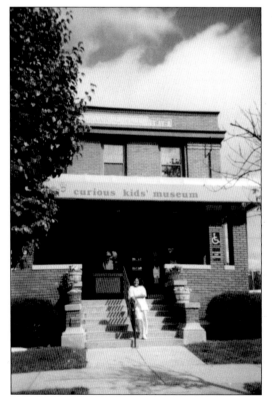

Sha'niqua DeFrance stands outside the current Curious Kids' Museum, established in 1989 at the former Grand Army of the Republic (GAR) Memorial Hall. Through donations of servicemen and citizens, the GAR erected the building in 1915. The Augustus W. Chapman Post 21 of the GAR initiated the project. Other veterans' organization met there through the years. (Photo by Elaine Thomopoulos.)

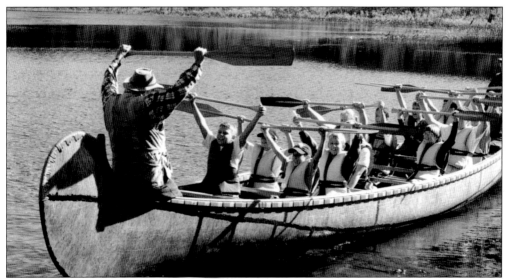

Chuck Nelson, director of Sarett Nature Center, teaches children how to row a canoe, just like the French voyageurs did when they came to this area for trade in the 17th and 18th centuries. Sarett's original 130 acres was acquired through the generosity of Elizabeth Upton Vawter and her husband William Vawter II. Dedicated in 1964, the nature center was named after Lew Sarett, a boyhood friend of William Vawter. Lew Sarett, a Russian Jewish immigrant who graduated from Benton Harbor High School, became a naturalist, poet, and Northwestern University professor. The nature center now has nearly 1,000 acres with 1,500 members and 10 to 15 staff. They serve over 25,000 students yearly. Also, nearly every weekend they present interesting nature programs for the community. Their Natural History through Travel program offers 12 trips each year throughout the country and the world. (Photo by Pat Moody of the Cornerstone Chamber of Commerce.)

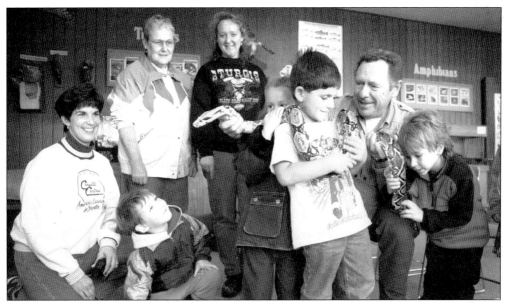

These youngsters comfortably handle the Sarett Nature Center snake under the guidance of Chuck Nelson. (Photo courtesy of Sarett Nature Center.)

The Fort Miami Heritage Society is an important part of the twin cities. The Priscilla U. Byrns Heritage Center, which opened in 1998, serves as home to the Fort Miami Heritage Society. The Society's educational programs and services include: public events and lectures, museum exhibitions, a research library and archive, the Frederick S. Upton Fellowship Program in Public History, and support for the preservation of historical buildings and neighborhoods. (Photo by Pat Moody of the Cornerstone Chamber of Commerce.)

The Krasl Art Center's ever-changing exhibits featuring the work of talented artists captivate thousands of people each year. The wise use of the Krasl's outdoor space showcases marvelous sculptural pieces. Children and adults learn from classes in the arts, lecture programs, and trips to art exhibits and museums. The highlight of each year is the Krasl Art Fair, held on Lake Bluff Park each July. (Photo by Pat Moody of the Cornerstone Chamber of Commerce.)

Five
TRANSPORTATION AND COMMUNICATION

This icy lighthouse illustrates the dangers that lighthouse keepers faced. Ferdinand Ollhoff, lighthouse keeper in the 1920s, had to crawl out to the lighthouse during an ice storm to light the light which had gone out, according to his son Norbert. Another time, ice froze over the catwalk atop North Pier and workers had to dig a trench 75 feet long to get to the lighthouse. (Photo courtesy of Fort Miami Heritage Society.)

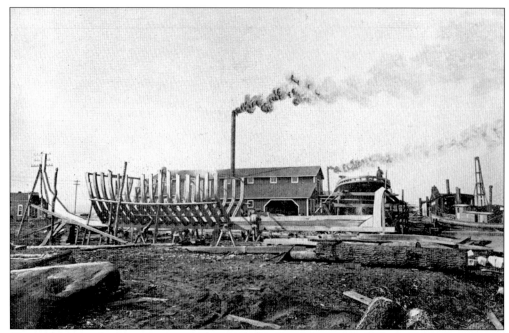

Shipbuilding has been important to the area's history ever since LaSalle's men built a ship at the mouth of the St. Joseph River in 1681. Pictured is a ship being built by E.W. Heath Company. (Photo courtesy of Fort Miami Heritage Society.)

Thomas H. Truscott emigrated from England to Chicago in 1870. By 1876, he was in Grand Rapids, where he and his sons, John, Henry, James, and Edward, founded the Truscott Boat Company. They built small wooden steam launches, sailboats, and rowboats, which were shipped throughout the United States as well as Europe. The company became one of the largest in the country. In 1892, they moved to St. Joseph. The company was producing 600 boats a year by 1905. Truscott built boats (gondolas) for both the 1893 Columbian Exposition and the 1933 World's Fair. In 1940, the company sold the business to Thomas Temple of Chicago, who kept the business going through World War II by building boats for the United States Navy. The company closed in 1950. (Photo courtesy of the Fort Miami Heritage Society.)

Sailing vessels preceded the steam ships in transporting products and passengers across Lake Michigan. After the steam ships started going across Lake Michigan and down the rivers, the majestic sailing vessels disappeared. (Photo courtesy of Fort Miami Heritage Society.)

The *Chicora* sank on January 21, 1895 between St. Joseph and Milwaukee. Fifteen crewmen, one passenger, and 38 carloads of flour were lost. This commemorative poster listed the names of the deceased and a poem in their honor, which helped ease the pain of the community. Earlier disasters included the 1868 sinking of the *Hippocampus*, where 26 passengers and crew drowned, and the *Alpena*, which lost all of her 60 to 100 passengers in 1880. The photo is by Harry Hughson. (Photo courtesy of Maud Preston Palenske Memorial Library, St. Joseph, Michigan.)

Jesse Calvin Davis, a porter on the *Chicora*, was only 23 years old when he lost his life because of the shipwreck in 1895. He left a widow and young child. During the summer, he was employed on the boats and in the winters by J.S. Morton. A memorial edition of the sinking noted, "He was a particularly bright and pleasant young colored man who was liked by every one." (Photo courtesy of Morton House Museum.)

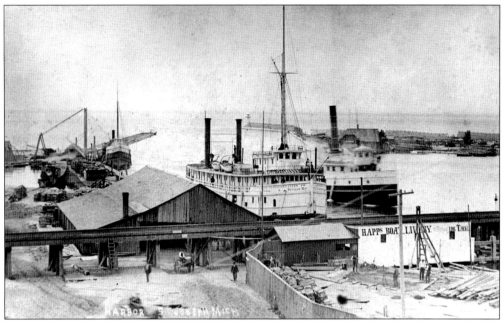

This is the St. Joseph Harbor in the early 1890s, with Happ's Boat Livery on the right. (Photo courtesy of Fort Miami Heritage Society.)

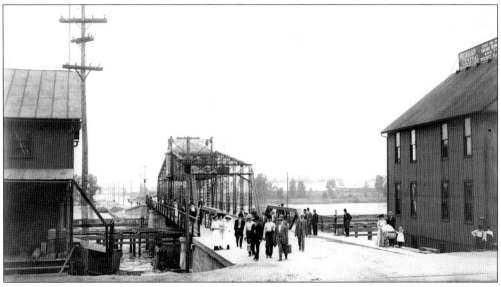

The explanation on the back of this photo states, "These travelers (note the suitcases) are probably crossing the State Street Bridge to catch the return boat home. The boat is docked (to the left) opposite the Silver Beach area. To the right you see the freight house of the Michigan Central Railroad, which disappeared in the 1920s when freight and passenger service declined. To the left stands a building of the Wallace Lumber Yard, which in the 1960s became part of the Urban Renewal program. Behind the bridge and to the right are some of the first buildings erected in the industrial district. The bridge replaced the uncertainty of a ferry service across the river and made it possible to open up the Edgewater district to industrial development." (Photo courtesy of Fort Miami Heritage Society.)

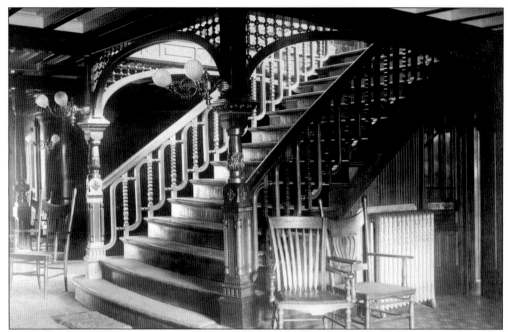

The passengers who traveled first class on the Graham and Morton steamships to and from Chicago traveled in luxury, with excellent accommodations and cuisine. This interior, from the *City of Chicago*, was charred beyond recognition in the fire that threatened the crew and passengers traveling to Chicago. Thank goodness no one was seriously injured. (Photo courtesy of Morton House Museum.)

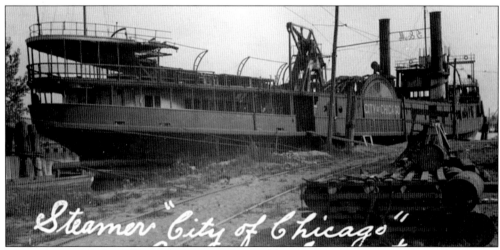

This sad postcard photo shows the burnt remains of the *City of Chicago*—a Graham and Morton Company ship—in 1914. The clear-headed ship's captain, Oscar Bjork, made a wise decision. Instead of jeopardizing the passengers' lives by having them use the lifeboats (this was just after the Titanic disaster) he made a desperate run for Chicago. His wireless radio went dead, so he couldn't even alert the rescue team in Chicago. With all passengers on deck, and with the fire spreading despite efforts of the crew to pour water on it, the boat tore into the Chicago's Lifesaving Station pier. Can you imagine the tears of joy as they all departed safely from the ship? (Photo courtesy of Benton Harbor Library.)

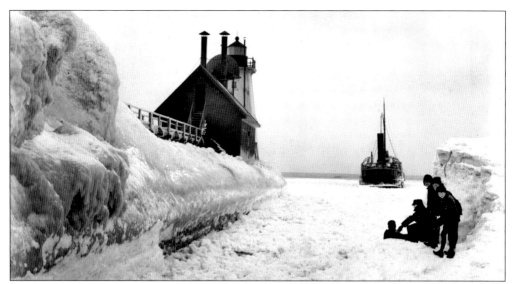

In January of 1898, the steamer *City of Duluth* became grounded as it tried to enter the harbor. Here the boat is engulfed in ice after the rescue of its passengers. It remained there until September when it was dynamited to rid the harbor of this hazard. During the rescue, the brave life-saving crew battled an icy north pier and terrible winds to bring their equipment to the end of the pier. Their Lyle gun shot the breeches buoy out to the worried passengers. One by one, the passengers sat in the breeches buoy and were brought to safety via a pulley. Volunteers from St. Joseph and Benton Harbor and the crew of the *City of Traverse* and the *City of Louisville* pitched in to assist. (Photo courtesy of Morton House Museum.)

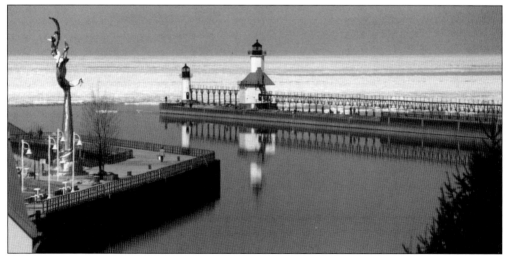

The United States Postal Service featured St. Joseph's lighthouse on the Great Lakes Lighthouse series issued in 1995. Boats coming into the harbor have been guided by lighthouses at the mouth of the St. Joseph River since 1832, when the first lighthouse was constructed. The lighthouse operates today has a catwalk. The catwalk was slated to be removed but it was saved through the Save the Cat Walk Committee, a group of concerned citizens. The sculpture in the photo was commissioned by the Krasl Art Center, through the generous donation of Judy Kinney in memory of her husband Patrick S. Kinney. World-famous artist Richard Hunt, who has a studio in Benton Harbor, created the sculpture. (Photo by Pat Moody of the Cornerstone Chamber of Commerce.)

In the fall of 1894, these ladies enjoyed riding their bikes, probably in the countryside. At the turn of the century there was an eight-mile bicycle track from St. Joseph to Stevensville. The ladies are identified as Jessie Sherwook Hartley (left) and Grace Sherwook Fuller (right). It looks as if they are wearing long dresses, but at the turn of the century some of the more daring women wore bloomers, a style inspired by the use of bicycles. The Bloomer Girl wore a middy blouse, bloomers just below the knees, and black cotton stockings—scandalous! (Photo courtesy of Fort Miami Heritage Society.)

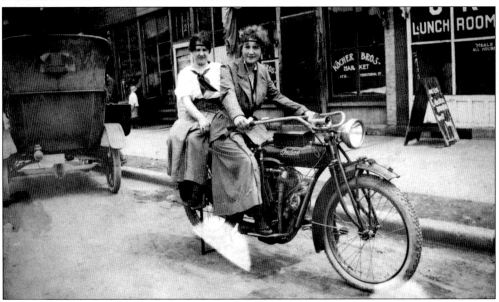

These attractive modern young ladies ride a motorbike outside the Koscher Bros. Market, located at 178 Territorial Street. The OK Lunch Room advertised, "Meals all hours." By 1920, women had become more liberated, finally obtaining suffrage. They had already gotten rid of their corsets, hoops, and bustles. The riding of bicycles and motor bikes were another step toward independence. (Photo courtesy of Benton Harbor Library.)

The Baushke Brothers are credited with manufacturing the first automobile made in America, which they accomplished in 1898 in their Benton Harbor Carriage Shop. Many members of the Baushke Family joined the House of David. (Photo courtesy of Fort Miami Heritage Society.)

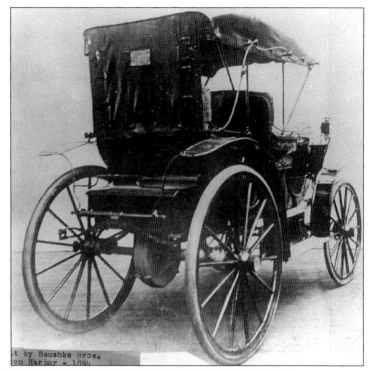

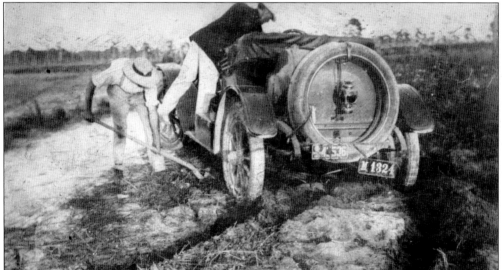

The driving conditions were atrocious whenever there was rain. Here a car is hopelessly stuck in the mud, c. 1913. Benton Harbor was originally a swamp. In the early days, especially after a rain, it was difficult to drive a horse and buggy from Benton Harbor to St. Joseph. In fact before the canal was developed, it would take much of the day to travel from Benton Harbor to St. Joseph, making it difficult for the farmers to get their produce to market. That is why Sterne Brunson, Henry Morton, and Charles Hull pushed to get a bridge built after Sprink's Bridge gave out. Not getting any cooperation from St. Joseph, they took subscriptions from Benton Harbor citizens so that the bridge and then a canal could be built. This got them on the road to becoming an important industrial force in the area. (Photo courtesy of Fort Miami Heritage Society.)

A fleet of taxis stands outside of the Premier Drug Company. The writing on the back of this photo says, "Deluxe Cab Co, John Elinir, owner, W. Main and 5th." There is a separate note dated September 6th, 1920, explaining, "We have seven cabs on this day. We took in $1,500. We put on the running boards, $1.00 per to the arena. Fitz [Floyd Fitzsimmons, who promoted the Dempsey fight] and I were good friends. During the time Dempsey was here, I drove him around and out to Eastman Springs everyday where they had training quarters. His sparing partners were Harry Greb, big Bill Tate and Panama Joe Gans. Dempsey would get out of cab and say, 'Come on Kid,' to watch him train." (Photo courtesy of Benton Harbor Library.)

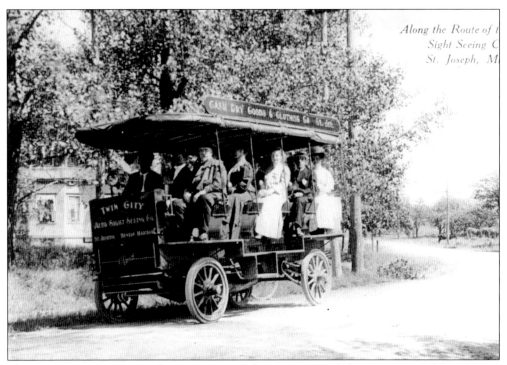

These passengers enjoy a sightseeing tour of the twin cities. (Photo courtesy of Fort Miami Heritage Society.)

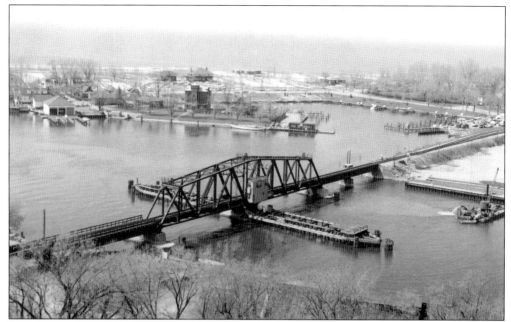

This aerial view of the Yacht Basin shows the railroad bridge, which was built in 1904. When boats need to pass, the bridge swivels and rests on the pilings seen in the photo. At the turn of the century, boats were used for industry and for transporting passengers back and forth to Chicago. Today's boats are mostly pleasure boats. (Photo courtesy of Fort Miami Heritage Society.)

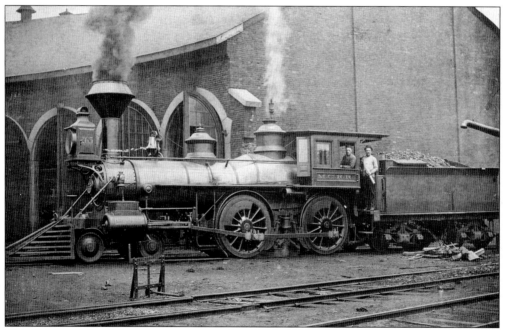

This Diamond Stack Locomotive was used in 1880–1890 by the Michigan Central Railroad. Having access to the railroad spurred the development of the agricultural, manufacturing, and tourism industries in St. Joseph and Benton Harbor. (Photo courtesy of Fort Miami Heritage Society.)

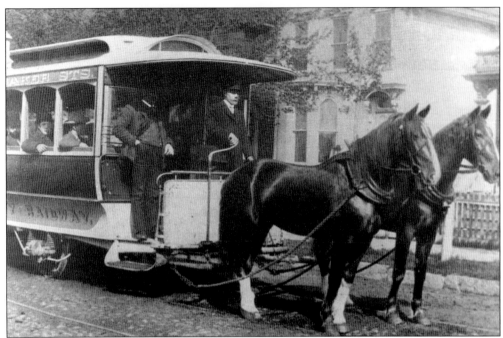

Robert E. Schultz in his book *Twin City Trolleys* reports that the St. Joseph and Benton Harbor Street Railway Company owned four passenger cars and started operating in October of 1885. One operator collected fares and then drove the two-horse team along the track. On a particularly steep hill, two horses could not manage. Another horse named Jumbo was brought in to help. (Photo courtesy of Fort Miami Heritage Society.)

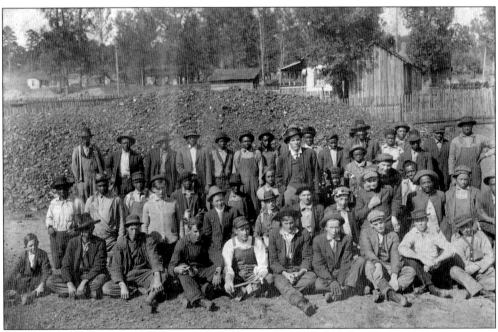

These hard-working men laid track for the Benton Harbor-St. Joe Railway, also known as the Twin Cities Railroad. (Photo courtesy of Fort Miami Heritage Society.)

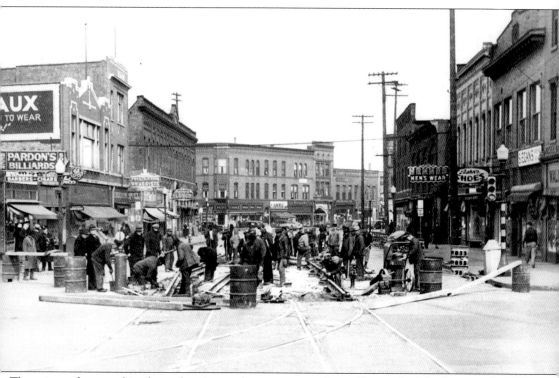

There is no date on this photo showing workers removing the trolley tracks. The last year for operation of the electric train was 1935. Automobiles had taken over. The Benton Harbor-St. Joe Railway & Light Company had 18 miles of city track connecting Benton Harbor and St. Joseph and charged 5¢ for the ride. The company also operated one interurban line which went to Paw Paw Lake and another that ran along the bank of the picturesque St. Joseph River to Dowagiac. The interurban became available all the way to South Bend. Robert E. Schultz in his book, *Twin City Trolleys*, reminisces about the electric streetcars: "The tracks and ties are gone. The poles, the wires, the stations are gone. The cars are gone, and everywhere there is only silence. Once there was the exciting clickety-clack of car wheels over rail joints, the steady hum of big electric drive motors, and the hiss of collector wheels on trolley wire. Alas, these are now but a memory." (Photo courtesy of Fort Miami Heritage Society.)

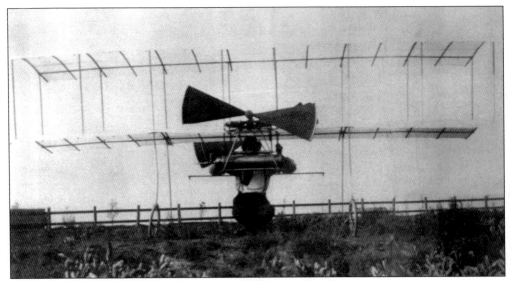

Augustus Moore Herring flew his flying machine at Silver Beach in St. Joseph in 1898, five years before the Wright brothers. With a wingspan of 18 feet and a length of 12 feet, it was powered by an engine that ran on compressed air. His first flight lasted about seven seconds and covered a distance of 50 feet. The next flight covered 72 feet. Unfortunately, he is not credited with building the first airplane since his craft had no practical control system, and was consider a glider-like aircraft. A plaque commemorating his flight appears along Silver Beach. (Courtesy of the Fort Miami Heritage Center.)

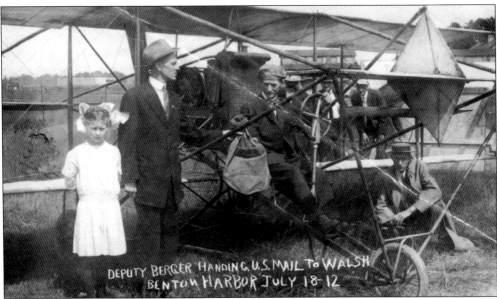

The handwritten caption at the bottom of this photo reads "Deputy Burger handing U.S. Mail to Walsh in Benton Harbor July 18, 1912." No airfields existed in Benton Harbor at this time. Sometimes airplanes took off from a cow pasture. In the 1940s, St. Joseph and Benton Harbor jointly developed Ross Field on the outskirts of Benton Harbor. With 224 acres, it had 100 feet of runway. The renovated airport (known as Southwest Michigan Regional Airport) continues operation. (Photo courtesy of Fort Miami Heritage Society.)

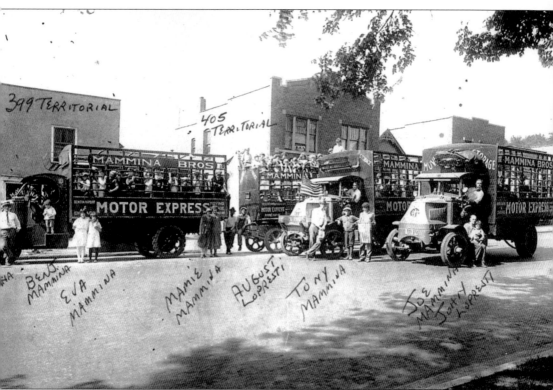

On a sunny day in 1925, these excited children from Calvin Britain Grade School went on a picnic to Silver Beach, transported by the trucks of the Mammina Brothers Motor Express. The Mammina brothers, Joseph and Ben, established the trucking business. Joseph's son, Ben Mammina, continued in the trucking business after his graduation from Notre Dame. He also worked as transportation director for the Benton Harbor School District. (Photo courtesy of Benton Harbor Library.)

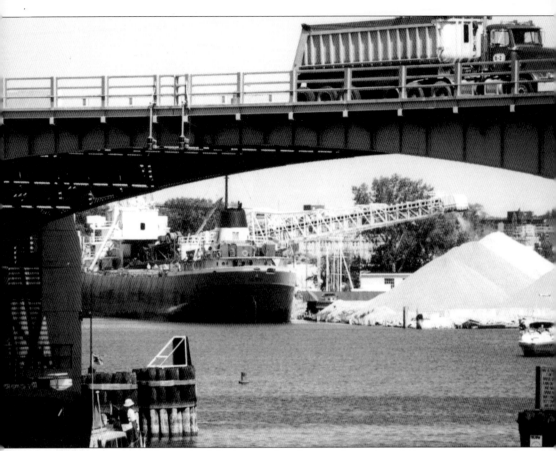

The truck on the Blossomland Bridge signifies the transformation of the transportation industry. Now the products of agriculture and manufacturing are transported mostly by trucks. Few commercial boats, such as the one illustrated, which serves Consumer's Concrete Corporation, come by way of the port. (Photo by Pat Moody of the Cornerstone Chamber of Commerce.)

Six
SPORTS, LEISURE, AND RESORTS

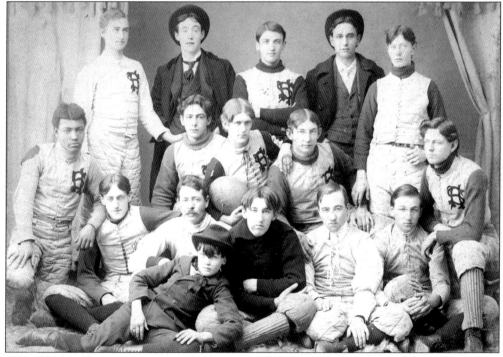

When Walter Banyon (sitting on the bottom right) donated this photo of the 1895 Benton Harbor football team, he noted, "The three outstanding players on this team were Ralph Schauman (bottom row, black sweater) who played center, Bert Hubbard (to the right of the player with the ball) who played left half, and Frank Busby (African-American player) who played right half. Hubbard was as hard to stop as (University of Michigan's celebrated back) Willi Heston, and Frank Busby was one of the most versatile athletes who ever played for Benton Harbor. Ralph Schauman was a brainy, brawny player who was never outplayed by an opposing center." Frank Busby died in the spring of 1900 from injuries sustained during the football season of 1899. His younger brother continued playing ball. In those years, the game was more dangerous—like a free-for-all. Also, the youth considered it unmanly to wear protective gear and what was available was not adequate, as can be seen in this photo. (Photo courtesy Fort Miami Heritage Society.)

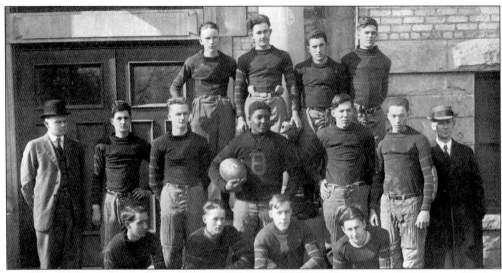

Sam Dunlap, pictured in the middle, served as team captain during the 1915 Benton Harbor football season. This is how he is described in the yearbook, "His name will be long remembered throughout the state as one of the best players ever seen in high school football." He played football for Western in 1915, 1916, 1917, and 1919. He took time off in 1918 to serve in World War I. An excellent athlete who played several sports, he won 11 letters. While he played football for Western, he scored 188 points and 30 touchdowns. He was the greatest punter in the school's history. In 1916, he scored 19 touchdowns, making him the highest scorer in the nation. That record was not broken until 1978. Because of his race, however, he suffered indignities. Although he was well-liked by his teammates, no one would room with him. A few new students threatened to quit the team if he remained. The coach told them they could take the next train back. A competing team threatened to cancel a game if Dunlap played for Western. Dunlap elected not to play. He, like many other talented young African-American athletes, did not get the opportunity to play professionally. That door was closed tight. When Dunlap, who was also gifted intellectually and could speak three languages, returned to his alma mater requesting a coaching position, he was hired as a janitor. Unfortunately, like many other talented young African Americans, he suffered discrimination and was not given the opportunities or recognition he rightfully deserved.

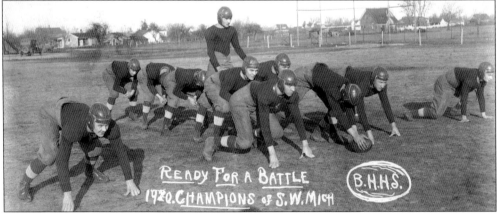

"Ready for a battle, 1920 Champions of Michigan," announced this photo of the Benton Harbor High School team. (Photo courtesy of Fort Miami Heritage Society.)

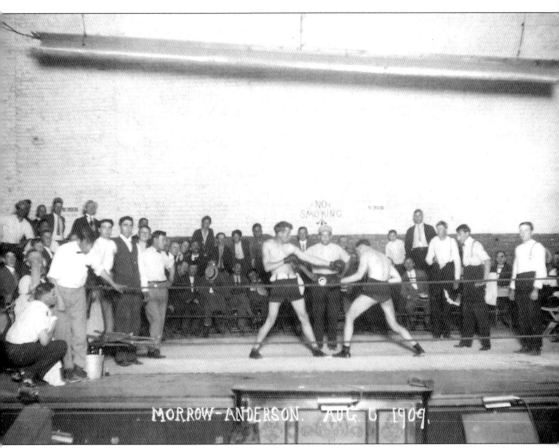

Few remember this 1909 fight between Benton Harbor native Howard Morrow and Anderson. A fight that Benton Harbor natives continue to talk about is the 1920 fight between Jack Dempsey, heavy weight champion, and contender Billy Miske. The fight was organized by Floyd Fitzsimmons Sr., who owned a large ball park on Fair Avenue. Thousands traveled to Benton Harbor to see Dempsey defeat Miske. As reported in the book, *A Flame of Pure Fire: Jack Dempsey and the Roaring '20s*, Chicago crime boss Al Capone approached Dempsey while he was in Benton Harbor, asking him to fight an exhibition at a private club he owned in Chicago. Wisely, Dempsey said no to getting involved with Capone and his mob. (Photo courtesy of Fort Miami Heritage Society.)

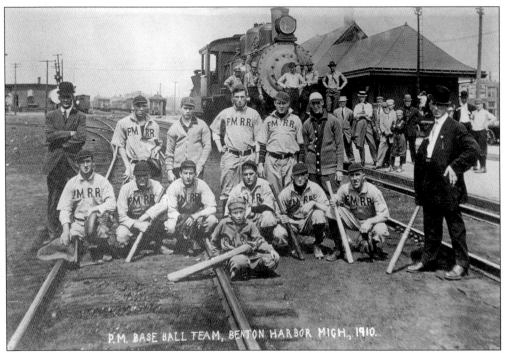
The Pere Marquette ball team poses outside the train station in 1910. (Photo courtesy of Fort Miami Heritage Society.)

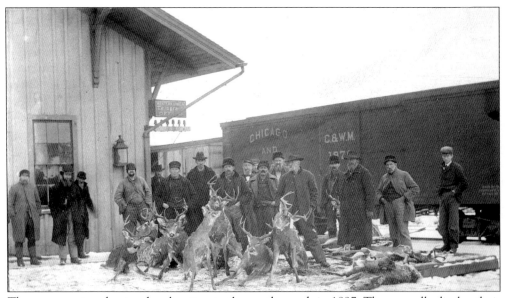
These men enjoyed going deer-hunting in the north woods in 1897. They proudly display their catch. (Photo courtesy of Fort Miami Heritage Society.)

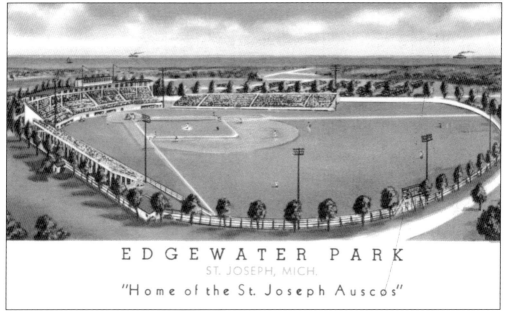

Old-timers recall the good old days watching ball at Edgewater Park. This "state-of the-art" facility had an automatic plate duster that would blow the dust off home plate with a flip of a foot switch, a microphone that came out of the ground, and a ball box that miraculously delivered 12 new balls out of the ground. The ball box and plate duster were donated to the Chicago White Sox, and the light and bleachers went to Waldo Tiscornia Park Baseball Field. (Photo courtesy of Fort Miami Heritage Society.)

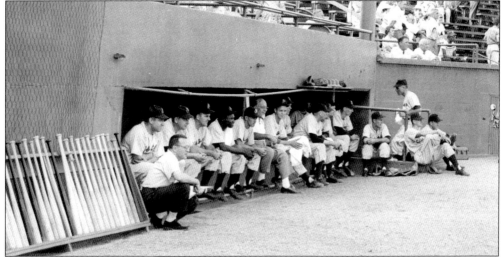

Auto Specialties became one of the top teams in the nation. They won the national semi-pro championship in 1946 in Wichita, Kansas. In 1958, they played the Chicago White Sox and attracted the largest crowd in Edgewater Park history: 5,300. Work at Auto Specialties and other foundries became a draw for African Americans and Caucasians from the southern states. Regarding working at Auto Specialties and Whirlpool, Rev. Donald Adkins said, "We made a decent living, could purchase a home, raise our families, and had pride in ourselves." (Photo courtesy of Fort Miami Heritage Society.)

Wrestler Bobo Brazil (Houston Harris) entertained screaming crowds in North and South America, Asia, Africa, and Europe, as well as in Benton Harbor, Michigan, with fights where he finished off his opponent with the "Coco Butt," a slamming of his forehead onto his unfortunate opponent's head. Bobo, who had his wrestling debut in 1951, became the first African American to achieve star status in the sport. He was called the "Jackie Robinson of wrestling." He weighed in at 280 lbs. and was 6 feet 6 inches tall, a real "giant of a wrestler." His long-time companion, Doris Rainey, called him "my gentle giant." Although brutal in the ring, he displayed gentleness and love to his children and friends. His daughter, Beverly Lewis, says, "We were crazy about him. He spoiled all his kids. He was a very good father and grandfather. He was fun and active and loved to play cards and fish. He liked to spend time with his friends. He was so friendly." His long career lasted over 40 years. He won Heavyweight Titles and was named Professional Wrestler of the Year from 1967 to 1972. In 1994, he was inducted into the World Wrestling Federation Hall of Fame. Besides wrestling, he operated Bobo's Grill on Fair Avenue for 20 years. He passed away at the age of 74 in 1998. As a tribute to him, the city of Benton Harbor named the Armory Building the Bobo Brazil Community Center. (Photo courtesy of Doris Rainey.)

This photo of Chet Walker is from the Benton Harbor High School yearbook. Walker, the baby in a family of ten children, came to Benton Harbor from Mississippi when he was nine years old. He played basketball for the former Syracuse Nationals (1963–1964), the Philadelphia 76ers (1964–1969), and the Chicago Bulls (1969–1975). While he played for the Bulls, he set a team single-game scoring record of 56 points. He scored 18,831 points in the NBA. In 1999, he was nominated to the Hall of Fame. In his autobiography, *A Long Time Coming: A Black Athlete's Coming of Age in America*, Walker tells of his struggles growing up, facing racism in Mississippi and in Benton Harbor, as well as the difficulties and joys of his basketball career at Bradley University and in the NBA. He stresses the impact of his mother's guidance and wisdom on his development. Walker currently works as an independent film producer. His films include *Freedom Road*, *A Mother's Courage: The Mary Thomas Story* (for which he won an Emmy), and *Father Clements*. Other professional basketball players from the twin cities include Anthony "Pig" Miller who played for the Los Angeles Lakers, and Quacy Barnes, who played in the women's league and is now an assistant coach at Indiana University. Professional baseball players include William Neal, who played for the Clowns in the Negro League, Don Hopkins, who played for the Oakland Athletics, and Dave Machemer, who played for the Angels and the Tigers. "Jelly Bean" Renolds played Canadian football, and more recently Rob Fredrickson played for the Raiders and the Lions.

William Seabolt, who learned to skate by watching movies of Sonja Henje at the Liberty Theater, won the 1941 First Place for Senior Men in Fancy Skating. Seabolt, a retired administrator for the Board of Education who has now returned to Benton Harbor, won this prize year after year in recognition of his athletic skill. (Photo courtesy of William Seabolt.)

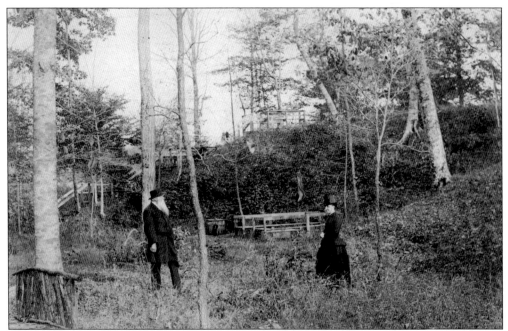

Harry Eastman, a Civil War colonel and former mayor of Green Bay, Wisconsin, stands with his wife at Eastman Springs. Colonel Eastman developed the Eastman Springs area in the 1880s and offered the water from the mineral spring for sale. The House of David purchased some of the property in 1908 and created an amusement park called Eden Springs. The City of David purchased additional property from them in 1945. (Photo courtesy of Fort Miami Heritage Society.)

Eastman Springs in Benton Harbor sold "Pure Sparkling Artesian Spring Mineral Water." The area was developed in 1883 and contained 27 artesian springs. The label was from a one gallon water jug and predates 1920. (Photo courtesy of Mary's City of David.)

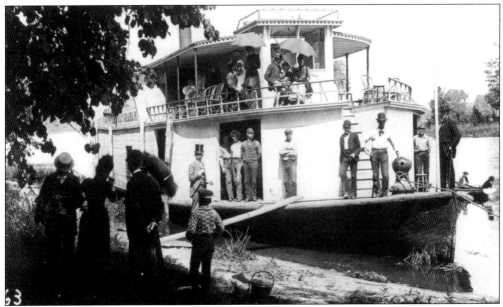

These passengers enjoyed the *May Graham, c.* 1884. The *May Graham* served vacationers and locals until 1908, when it was replaced by the interurban (an electric street car) as a faster means of transportation from St. Joseph to the resorts. The steamer not only served as a vehicle, but as a relaxing way to spend a summer day or a church picnic. An advertisement notes, "It goes up the winding stream for 25 miles stopping at a score of landings, each of which seems more delightful than all the others for a day's picnic." Beloved Captain Fikes was the captain of the *May Graham* for many years. (Photo courtesy of Fort Miami Heritage Society.)

This is a dramatic view of Higman Park, on the coast of Lake Michigan. You can see people on top of the ridge. With such lovely scenery, Higman Park became a resort. Lots were also available for the building of summer and full-time residences. (Photo courtesy of Fort Miami Heritage Society.)

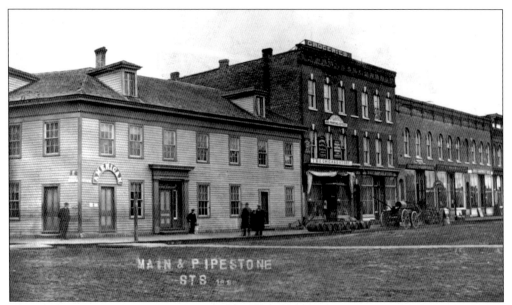

This is the corner of Main and Pipestone Streets in St. Joseph, c. 1890. The American House, a frame hotel, was completed in 1862 and operated for several years by Mr. Whiting and later operated by Martin Dodge, Ed Nichols, and Alonzo Vincent. (Photo courtesy of Benton Harbor Library.)

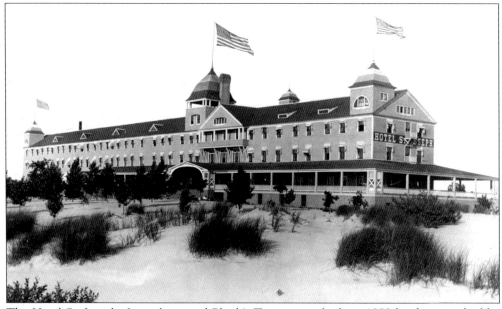

The Hotel St. Joseph, formerly named Plank's Tavern, was built in 1889 by the same builder who built the Grand Hotel at Mackinac Island. Guests enjoyed the wrap-around porch and beautiful views of either Lake Michigan or the St. Joseph River from each of the rooms. The luxury hotel boasted steam heat, electric lights, running water, bathrooms on every floor, and electric call bells. It also had a dancing pavilion, bath houses at the beach, and a boat livery. In 1893, the hotel was sold and renamed Hotel St. Joseph. In it 1898, it tragically burned down. (Photo courtesy of Fort Miami Heritage Society.)

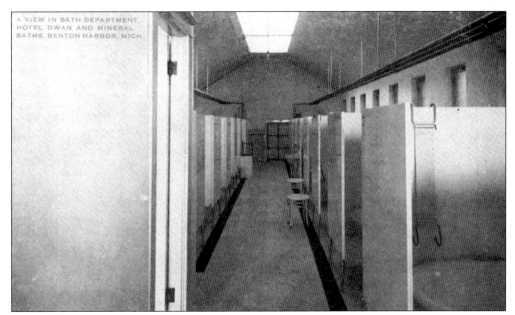

The Dwan Hotel's patrons used these tubs for bathing in the mineral waters. Gerry Essig of St. Joseph described the mineral baths as "smelling like rotten eggs." No matter, the people who frequented them faithfully believed in their restorative powers. In 1945, the Saltzman Hotel, which also offered baths, advertised, "Forty years experience curing Rheumatism, Nervousness, Arthritis, Poor Circulation, etc." (Photo courtesy of Fort Miami Heritage Society.)

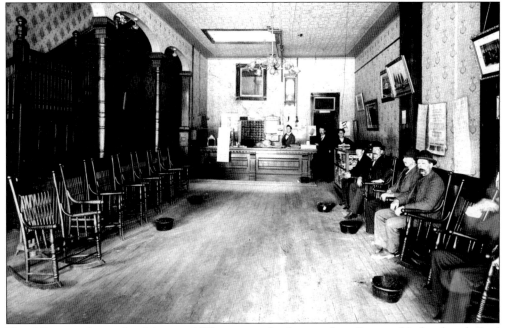

Hotel Benton, located at Main and Water, was the first modern Benton Harbor hotel. Fred Culline sits at the desk and to his right is Bob Ricee, in charge of baggage, train, and boats, and Dick Murray, clerk. Note the spittoons, rocking chairs, and the wooden stairway on the left. (Photo courtesy of Fort Miami Heritage Society.)

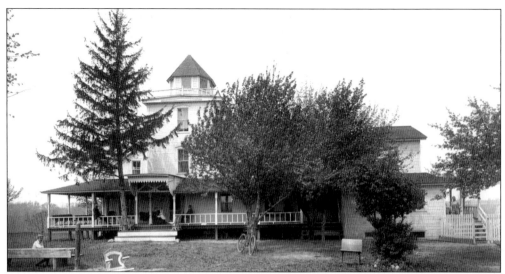

The Emery Fruit Farm Resort, located in Benton Harbor along the St. Joseph River, pictured here in 1892, was later purchased by Greeks and served as a favorite vacation destination for the Greek-American community from the 1920s to the 1950s. Eugenia Georgoules Sieffer, niece of one of the owners of the resort, describes it: "In the evening they used to congregate on the verandah on wicker chairs and play cards. In the living room, I played and sang Greek songs on the piano, and the people used to dance Greek. The men would play cards, dance, and sing. They had a slot machine. The food was excellent. My uncle and my brother got lambs from a lamb farm in Stevensville. My uncle would slaughter the lambs and the Greek chef would cook them. There were fresh vegetables and fruit—a peach orchard and apple trees were on the property. They would ring a cowbell for lunch and dinner. Sometimes there would be 100 guests for dinner." (Photo courtesy of Fort Miami Heritage Society.)

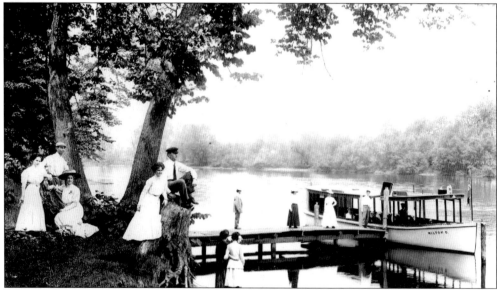

Ladies and gents dressed in turn-of-the-century finery appear as it they are in an idyllic painting. They are on the wooded shores of the St. Joseph River, with the boat *Milton D.* to the right. (Photo courtesy of Fort Miami Heritage Society.)

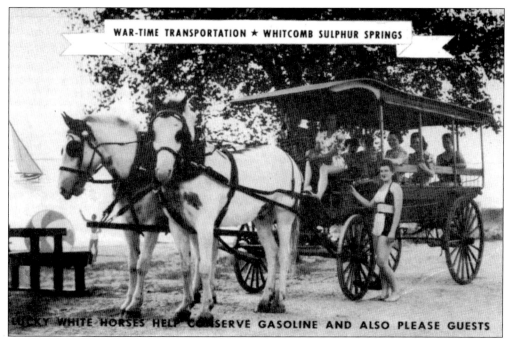

The horse and buggy returned during World War II because of gas rationing. The caption advertising the Whitcomb Hotel in Benton Harbor reads, "The horses help conserve gasoline and also please guests." During World War II, the number of summer guests dwindled because of gasoline rationing and the war effort. Young men joined the Armed Forces, and women worked in wartime industries. (Photo courtesy of Fort Miami Heritage Society.)

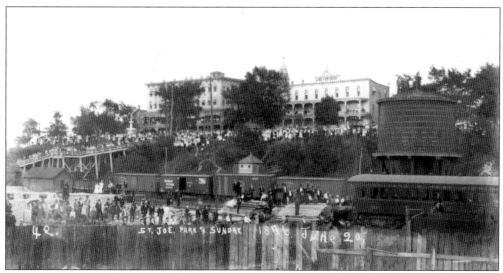

In this photograph, taken from the St. Joseph Lake Bluff Park in 1896, you can see the Whitcolm Hotel, the Lake View Hotel, and the Michigan Central and Chicago and West Michigan Railroads. The Whitcomb Hotel was known as the Whitcomb Sulphur Spring Hotel after being remodeled in 1875 from the earlier Saint Charles Hotel erected in 1868. The original Whitcomb Hotel was demolished and a new hotel erected in 1928. It now serves as a retirement residence. (Photo courtesy of Fort Miami Heritage Society.)

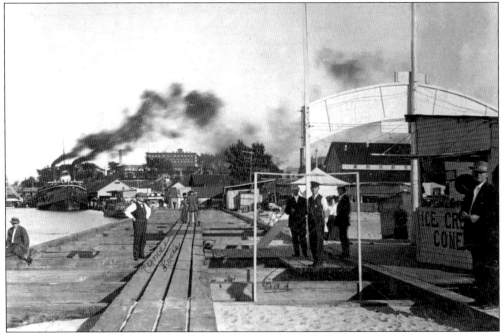

This photo (c. 1915) of Silver Beach shows the old Whitcomb Hotel and a Graham and Morton coal-burning side-wheeler. Note the tugboat which towed sailing boats in and out of the harbor. The notation on this photo identifies the man in the vest as Louis D. Wallace and to the left of the captain is L.J. Drake. Wallace and Drake developed Silver Beach as an amusement park. (Photo courtesy of Fort Miami Heritage Society.)

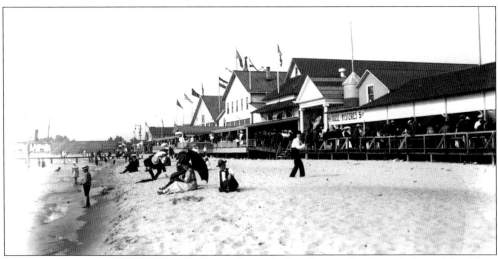

This view of Silver Beach looking northeast shows the beach, boardwalk, and shops. The Silver Beach boardwalk included "House of Mysteries: 5 cents." The boardwalk, installed in the 1920s, was gone by the 1930s, replaced by cement. During the early years, a heated swimming pool, roller skating rink, and dance pavilion delighted the locals and the many tourists who came by boat from Chicago. Weary dancers danced the night away at the Marathon Dances held at the Pavilion during the 1930s. (Photo courtesy of Fort Miami Heritage Society.)

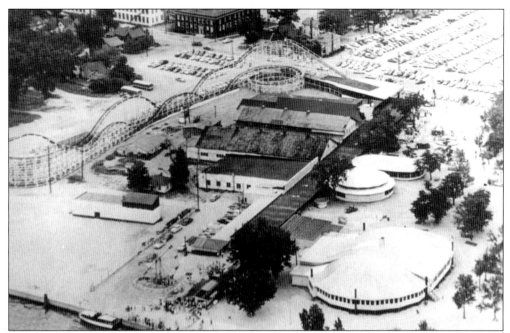

This aerial view of Silver Beach brings back fond memories. During the early years, a heated swimming pool, a roller-skating rink, and a dance pavilion delighted the locals and the many tourists who came by boat from Chicago. Concessions and rides were added, including revolving World War I airplanes suspended from cables. Later came the merry-go-round, the bowling alley, the roller coaster, the fun house, and Shadowland Ballroom. Chief Terrill, Logan's son-in-law, took over the operation of the amusement part after Logan's death in 1947. In 1972, Terrill closed the park, and by 1975, it was demolished. (Photo courtesy of Fort Miami Heritage Society.)

The c. 1922 caption from the Klock album reads, "Are we 'It'?" with the response, "Well, I guess." The term "it" was slang first used to describe Clara Bow, a sexy movie actress, who had "it." (Photo courtesy of Fort Miami Heritage Society.)

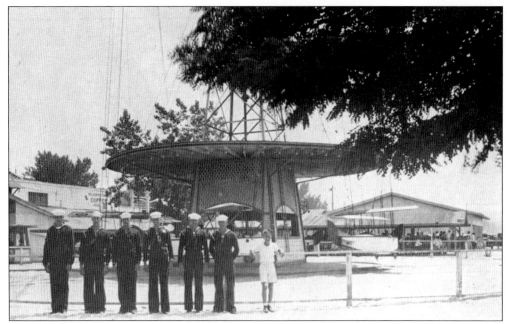

An exciting Silver Beach addition in 1910 was a airplane ride consisting of six pre-World War I designed planes, suspended from cables and attached to a motorized revolving top. It commemorated the plane which Herring built and flew off Silver Beach, five years before the Wright brothers. Other attraction later added included the merry-go-round, the bowling alley, the roller coaster, the fun house, and Shadowland Ballroom, which featured big band music and was a popular place for young couples to meet and even get married. (Photo courtesy Maud Preston Palenske Memorial Library, St. Joseph, Michigan.)

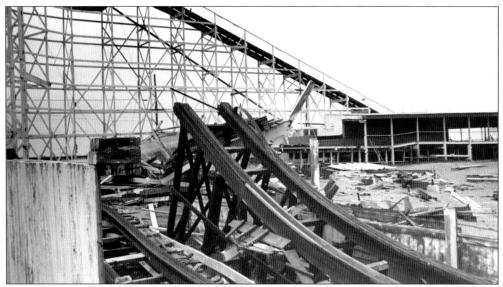

This photo (c. 1975) shows the demise of the famous Silver Beach roller coaster which delighted thousands of children and adults over the years. Many enjoyed the merry-go-round, the fun house, and Shadowland Ballroom, where many a couple met and got married. In 1972, Chief Terrill closed the park. (Photo courtesy of Fort Miami Heritage Society.)

Seven
HOUSE OF DAVID

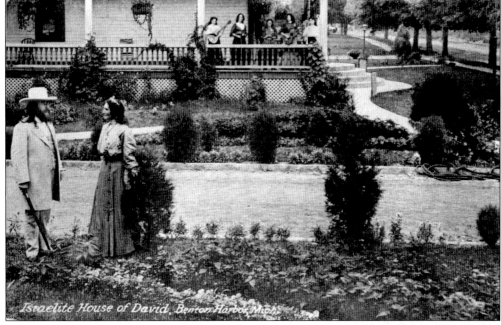

Pictured above on the left of the photo are the late Mary and Benjamin Purnell, leaders of the Israelite House of David. The Israelite House of David await the millennium and the second coming of Christ. They believe that at this time, 144,000 worthy couples gathered from the 12 tribes of Israel will be received body and soul into a "heaven on earth," and that these couples will have children who will lead the world into a perpetual state of harmony and connection to God. Celibacy, they believe, is a way of purifying themselves in preparation for the second coming.

They understand that God sent his teachings concerning the second coming of Christ through seven divine messengers. The first messenger, Joanna Southcott, was born in England in 1792. Six other messengers followed her death in 1814. In 1903, Benjamin and Mary Purnell gathered together followers of the Israelite House of David religion, believing that they had been selected by God as the seventh messenger.

Although Mary and Benjamin came to Benton Harbor accompanied with only five followers, the religion thrived, and by 1919, they had 1,000 members who came from all parts of the nation, and even as far away as Australia. Many came as couples, bringing their children.

Financially they did well because of astute business management and talented membership. They set up an amusement park which thousands flocked to each summer. They also had traveling baseball teams, as well as renowned musicians who gave concerts throughout the country. Their farms produced so well that they not only had enough produce to satisfy their own needs, but profited through sales at the Benton Harbor Fruit Market. They also produced glistening ceramic objects prized as collector's items. They all worked hard toward a common goal of preparing for the millennium, abstaining from selfishness and lust. When they joined the House of David, they freely contributed their worldly possessions in order to participate in the communal life which would prepare them for the millennium reign of Christ on earth. They became self-sufficient—producing their own food, making their own clothing, and designing and constructing new buildings as the community grew.

In the 1920s, however, trouble brewed. There were court battles that Mary Purnell described as, "Legal battles that the State of Michigan waged against the House of David, trying to dissolve it because of a conspiracy against Benjamin by disgruntled women members who wanted money."

More trouble followed the death of Benjamin Purnell in 1927. There was a split between the followers of Mary and the followers of Judge H.T. Dewhirst, a former California judge who had joined the colony in 1921. Those who rallied behind Mary believed that both Mary and Benjamin together were the seventh messenger. The followers of Dewhirst believed that only Benjamin held that role. In 1930, when Dewhirst cut Mary off from any leadership role in the community, she established her own community down the road from the original colony. She named it the Israelite House of David as Reorganized by Mary Purnell or Mary's City of David, to differentiate it from the other group. Dewhirst's group retained the name Israelite House of David. Half of the colony's members (217) left with Mary and the other half (218) remained with Dewhirst. Both communities thrived into the 1960s despite the emotional toll the legal battles and the split caused. In the 1970s, however, membership declined. Because of the practice of celibacy, the members did not have children to perpetuate the religion. (Photo courtesy of Maud Preston Palenske Memorial Library, St. Joseph, Michigan.)

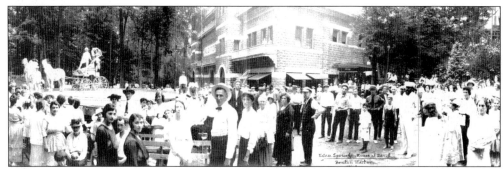

The photo by Harry Kirkham shows the park in 1919. Notice the acrobat and the horses. Free admission and free entertainment was a draw for those who came to Eden Springs Amusement Park. Seen in this photo is the auditorium where Benjamin and Mary Purnell conducted their religious meetings, pageants, and programs. (Photo courtesy of Mary's City of David Museum Archive.)

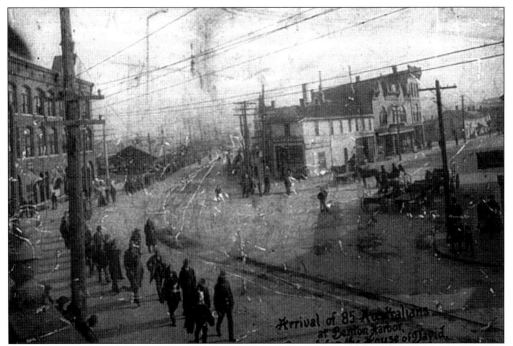

This dramatic photo shows the 85 Australians who paraded down Water Street on route to the House of David in 1905. Their interest in the colony was a result of Benjamin and Mary's trip to Melbourne, Australia, in 1904. These 85 followers of the fifth messenger, the deceased John Wroe, came to join Ben and Mary Purnell in Benton Harbor to establish the seventh church. (Photo courtesy of Mary's City of David Museum Archive.)

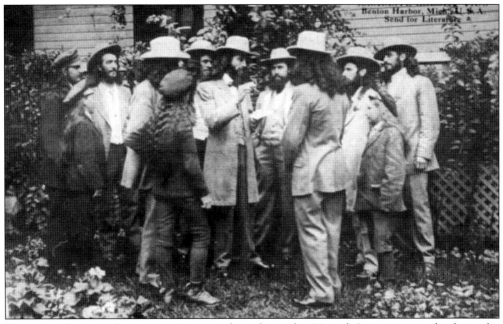

These Israelite preachers, c. 1907, went throughout the United States to preach about the millennium reign of Christ on Earth. (Photo courtesy of Mary's City of David Museum Archive.)

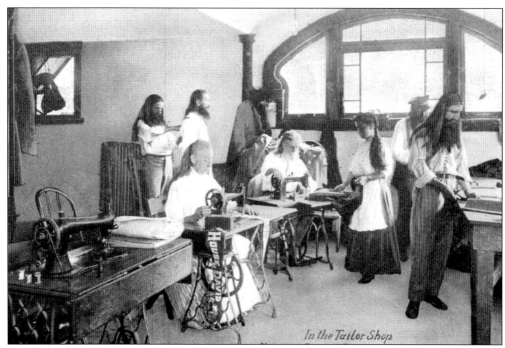

The House of David became self-sufficient, with the Israelites even sewing their own clothes in this tailor shop as well as growing and baking their own food, constructing their own buildings, and generating their own electricity. Note that both men and women worked in the tailor shop. (Photo courtesy of Maud Preston Palenske Memorial Library, St. Joseph, Michigan.)

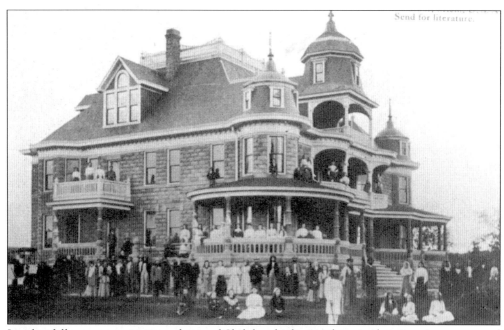

Israelite followers are congregated around Shiloh, which served as an administrative center and living quarters. It was built in 1908 to accommodate the growing Israelite community, which at this time exceeded 750. (Photo courtesy of Mary's City of David Museum Archive.)

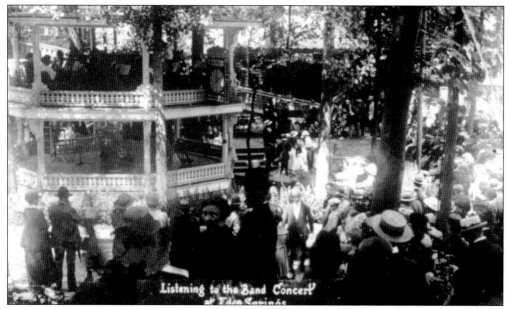

The amusement park amassed thousands of visitors. When the band or orchestra played on the top of this double-decked building, the music reverberated throughout the park. People packed the park even in the midst of the depression in the 1930s. To economize, local families brought their lunch. Since admission was free, they spent very little money (perhaps only on the train ride and a waffle cone.) They enjoyed the zoo, and free live entertainment such as the band or orchestra, and even vaudeville shows. (Photo courtesy of Mary's City of David Museum Archive.)

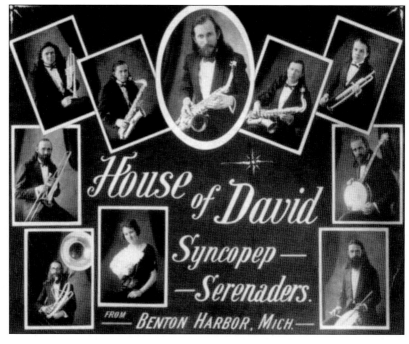

A traveling jazz bands of the 1920s, the Kings of Syncopation were trained under the tutelage of Joseph Hannaford, one of the 85 Christian Israelites who traveled from Melbourne, Australia. They played to huge crowds, including 12,231 at the Cleveland Public Auditorium. They played in Los Angeles, New Orleans, and the Cotton Club. (Photo courtesy of Mary's City of David Museum Archive.)

The top of this flier shows the synagogue used by Mary's City of David's Jewish guests from 1938 to 1976. Ron Taylor of Mary's City of David describes the Jewish resort built at the Christian colony, "The resort started in 1930 with log cabin structures using field stones from the land clearings at the farms, and logs from standing trees on the farm properties. The usage of their own natural materials helped with costs (during the Great Depression era)and gave the early accommodations a rustic and quaint look. The last year of building cottages for Jewish summer guests was 1948; that means they were building for 18 years to keep up with the increasing demand each summer."

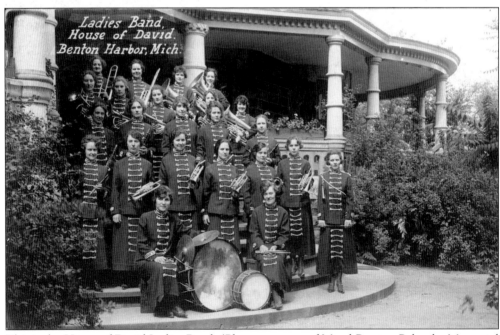

This is the House of David Ladies Band. (Photo courtesy of Maud Preston Palenske Memorial Library, St. Joseph, Michigan.)

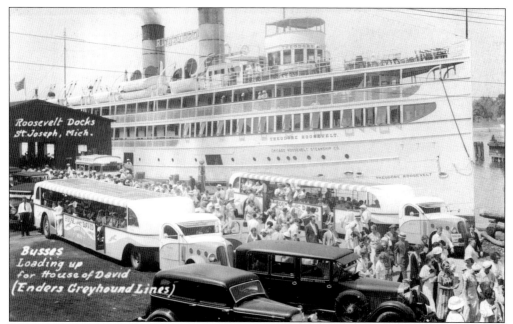

House of David buses met passengers departing from the *Theodore Roosevelt* and took them directly to the park. The *Theodore Roosevelt* operated until the 1950s. Thousands would come from Chicago each year to enjoy the amusement park. (Photo courtesy of Maud Preston Palenske Memorial Library, St. Joseph, Michigan.)

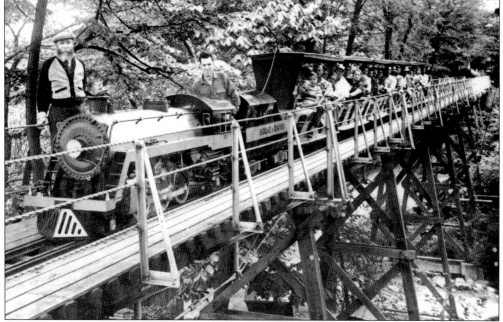

Miniature trains delighted House of David visitors for 65 years. The first train started operation in 1908 with a 4-4-0 American Standard type of locomotive. One train was not sufficient to handle the demand, so the House of David engineers disassembled the train and made four additional engines. (Photo courtesy of Maud Preston Palenske Memorial Library, St. Joseph, Michigan.)

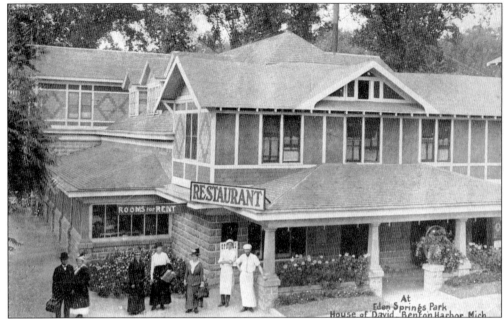

Since the Israelites did not eat meat, they served only vegetarian food at their restaurants. Peter Giannos, a summer visitor, reports he ordered the "steak," not knowing it was not meat, and thought it was one of the most delicious meals he had ever eaten. Mary's City of David continues to serve vegetarian lunches, based on a 1934 menu, on Sundays during the summers. (Photo courtesy of Maud Preston Palenske Memorial Library, St. Joseph, Michigan.)

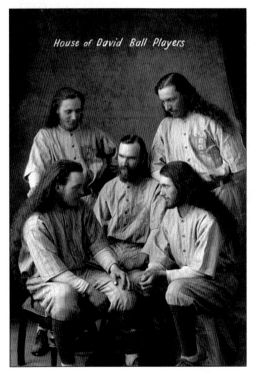

The House of David baseball players enjoy a bit of quiet away from the maddening crowds of spectators. Both the House of David and Mary's City of David continued playing baseball after the split in 1930, the House of David until 1937 and the City of David until 1955. Baseball continues to be played by a House of David Echo Vintage Team. Unlike the original House of David teams that played by modern rules, today's team plays by rules from the "gentleman's game" of 1855. The rules include not throwing a fast ball and getting an out on a bounce as well as a fly. The umpire can ask ball players or spectators about how to call a play he is not sure about, and he can fine ballplayers a quarter if they spit, curse, scratch, or use alcohol or tobacco. Like the original House of David teams, ball players outside of the House of David can join the team, with the stipulation that they grow a beard. (Photo courtesy of Mary's City of David Museum Archive.)

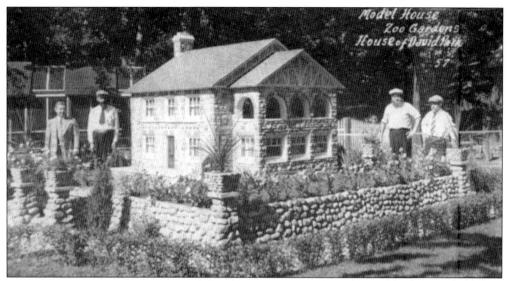

The Israelites, under the direction of designer and builder John Herron, created this miniature house using 1,600 stones they gathered from the fields and along Lake Michigan. (Photo courtesy of Mary's City of David Museum Archive.)

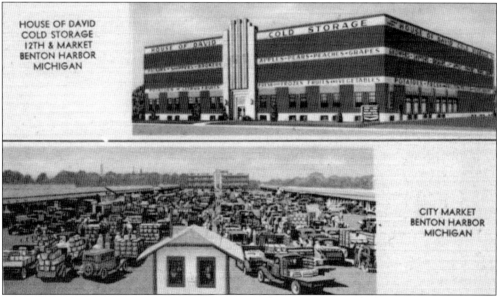

Pictured in this post card is the House of David Cold Storage and the Benton Harbor Fruit Market. The House of David sold their produce at the fruit market, since they operated several productive farms throughout the area. When Benjamin Purnell started the House of David at the beginning of the century, he purchased farm acreage, including High Island, a wilderness logging area in northern Michigan. The produce grown on the farms contributed to making the area's fruit market one of the largest fruit markets in the world. After the split in 1930, both the House of David (under the leadership of Dewhirst) and Mary's City of David continued producing fruits and vegetables on their farms. During World War II, Dewhirst conceived of the idea of bringing in German Prisoners of War to work the farms. (Photo courtesy of Mary's City of David Museum Archive.)

BIBLIOGRAPHY

Abbott, Diane. *The Lower Peninsula of Michigan*. Lansing, Michigan Department of State, 1976.
Adkins, Clare. *Brother Benjamin*. Berrien Springs, Andrews University Press, 1990.
Anderson, Eleanor. "Benton Harbor Fruit Market." *Fort Miami Newsletter*.
Anderson, Eleanor. "Truscott Boats." *Fort Miami Newsletter*.
Anderson, Eleanor. "Al Capone and the Society Ladies." *Fort Miami Newsletter*.
"An Historical and Architectural Overview of the Old St. Joseph Historic District."
Armstrong, John. *The Way We Played the Game*. Naperville, Sourcebook, Inc. 2002.
Ast, William, "Ceremony to Commemorate German Settlement." *The Herald-Palladium*, June 14, 2002.
Baillif, Jeff. "History of St. Joe Fire Department." Unpublished paper. 1975.
Banyon, Walter. "Ex-Slave Became a Leader in City's Religious Life." April 1, 1950/
The Benton Harbor Fruit Market, Present and Proposed Facilities. Washington, D.C., Government PrintingOffice,1960.
Benton Harbor: the Metropolis of the Michigan Fruit Belt. M.W. Alger, 1915.
Benton Harbor High School Yearbooks. Benton Harbor, Michigan. 1915, 1958, 1964, 1974.
Benton Harbor Improvement Association. Benton Harbor, Michigan, 1891.
Benton Harbor, Michigan: Educational, Commercial, Industrial, Financial. Date unknown.
"Born a Slave, He Fought For Lincoln." *The News-Palladium*. March 27, 1914.
By the Waters, Benton Harbor Centennial, 1866–1966. Benton Harbor, Benton Harbor Centennial Association, 1966.
Cantor, Judith. *Jews in Michigan*. East Lansing, Michigan State University Press, 2001.
A Centennial History of St. Joseph Parish. St Joseph, St. Joseph Catholic Church.
A Century of Faith 1865 to 1965. St. Joseph, St. Joseph Catholic Church, 1965.
Champion, Ella. *Berrien's Beginnings*. Niles, Trust Department of the First National Bank of Southwestern Michigan, 1926.
Chancey, A.E. *Berrien Country, A Nineteenth Century Story*. 1955.
Chauncey, A.E. *History of Berrien County*.
"City's Best Known Colored Man Survivor of 'Uncle Tom' Days." *The News-Palladium*. April 11, 1921.
Claspy, Everett. *The Dowagiac-Sister Lakes Resort Area and More about its Potawatomi Indians*. Dowagiac, 1970.
Claspy, Everett. *The Negro in Southwestern Michigan*. Dowagiac, 1967.
"Colored Methodist Church." *The Daily Palladium*. April 2, 1902.
Coolidge, Judge Orville. *A Twentieth Century History of Berrien County*, Michigan. Chicago, Lewis Publishing Co., 1906.
Cornerstone Alliance. "Tales of the Community." Brochure. Benton Harbor, Cornerstone Alliance, 2001.
Cowles, Ed. B., Compiler. *Berrien County Directory and History*. Buchanan, Record Steam Printing House, 1871.
Cunningham, Wilbur. *Land of Four Flags*. Grand Rapids, William B. Eerdmans Publishing Co., 1961.
Cunningham, Wilbur. *Letter Book of William Burnett*. The Fort Miami Heritage Society of Michigan, 1967.
Cunningham, Wilbur. The History of Carey Mission. 1956.
Davis, Henry. *Social Changes in Western Michigan*. Kalamazoo, Western Michigan University Press, 1997.
Dearning, M.R., *Veterans in Politics, the Story of the GAR*, 1952.
Dunbar, Willis. *All Aboard: A History of Railroads in Michigan*. Grand Rapids, William Eerdmans Publishing Company, 1969.
Eckert, Kathryn, *Building of Michigan*. New York, Oxford University Press, 1993.
Edmunds, R. David, *The Potawatomies: Keepers of the Fire*. Norman, University of Oklahoma Press, 1978.
Elliott, Frank. *When the Railroad Was King*. Lansing, Michigan History Division Michigan Department of State, 1977.
Gehres, Thelma and Jo Gardner. *Ye Old Landmarks*. Benton Harbor, Paper prepared for the 1965 Community Resources Workshop—Michigan State University.
Gilpe Edmunds, David. *The Potawatomis: Keepers of the Fire*. Norman, University of Oklahoma Press, 1939.
Graff, George. *The People of Michigan*. Lansing, Michigan Department of Education, 1974.

Gilpin, Alec R. *The Territory of Michigan (1805-1837)* Michigan State University Press, 1970.
The Good Ole Days in the Twin Cities 1888-1957. Benton Harbor, Farmers and Merchants Bank, 1957.
Gorr, Herbert. *Old St. Joseph Historic District.* The Fort Miami Heritage Society, 1982.
Hatch, Robert. *The Story of Junius Hopkins Hatch.* St. Joseph, 1994.
Harrison, Timothy. "St. Joseph Pier Lights." *America's Lighthouse News Magazine.* June 1995.
Headlight Flashes: Benton Harbor and St. Joseph, Mich. 1898.
The History of Rosback: 1881-1981. Benton Harbor, 1981.
I Know My Community, Survey Committee of the Coordinating Council of St. Joseph and Benton Harbor. Oct. 1942, Revised Dec 1994.
Headlight Flashes: Benton Harbor and St. Joseph, Michigan. 1898.
Heritage Journal: The Newsletter of Fort Miami Heritage Society. Fall, 2001, Spring 2002, Fall, 2002, Spring, 2003, Winter, 2003.
History of Berrien and Van Buren Counties, Michigan. Philadelphia, D.W. Ensign Co., 1880.
Holtzman, Robert. *Fabulous Fruits of Freedom: A Historical Pageant Commemorating the 200th Year of America and Berrien County.* Fostoria, OH, 1976.
"House of David Echoes BBC VS. Friend of Faith, Eau Claire, MI." Baseball Programme, July 5, 2003.
I Know My Community, St. Joseph and Benton Harbor Community Study. 1944.
Johnson, Karen P. "Captain Boughton: 'Captain' of the Fruit Industry." *Fort Miami Heritage Newsletter*, p.3.
Kahn, Roger. *A Flame of Pure Fire, Jack Dempsey and the Roaring '20s.* New York, Harcourt Brace & Company. 1999.
Kotlowitz, Alex, *The Other Side of the River.* New York, Bantam, Doubleday, Dell Publishing Group, Inc., 1998.
Lane, Kit. *Chicora: Lost on Lake Michigan.* Douglas: Pavilion Press, 1996.
League of Women Voters. *Know Your Twin Cities, Benton Harbor-St. Joseph.* 1963.
Lieberman, Karla, *North Lincoln School, 1860–1983.* St. Joseph, North Lincoln PTA, 1983.
McConnell, Edith. *A History of St. Paul's Episcopal Church in St. Joseph, Michigan.* Revised 1962.
May, George. *Pictorial History of Michigan.* Grand Rapids, William Ferdmans Publishing Company, 1969.
May, George. *Michigan: An Illustrated History of the Great Lakes State.* Windsor Publications, 1987.
"Memories of Early Theatres." *Herald-Palladium.* Benton Harbor-St. Joseph, Michigan. November 17, 1978.
Mitchell, Warren. "Yesteryear's Memoirs." Unpublished paper.
Momany, Chris. *Memorial Hall: A Bridge in Time*, unpublished paper prepared for the City of St. Joseph, 1982.
Morton, J.S. *Reminiscences of the Lower St. Joseph River Valley.* Benton Harbor, Federation of Women's Clubs, date unknown (before 1936).
M., J. S. (Probably Morton) Unpublished paper on Benton Harbor. Benton Harbor, 1935.
Moulds, Catherine. *Chips Fell in the Valley.* 1963.
Myers, Robert. *Historical Sketches of Berrien County.* Berrien Springs, Berrien County Historical Association, 1988.
Myers, Robert. *Historical Sketches of Berrien County, volume 2.* Berrien Springs, Berrien County Historical Association, 1989.
Myers, Robert. *Historical Sketches of Berrien County, volume 3.* Berrien Springs, Berrien County Historical Association, 1994.
Myers, Robert. *Historical Sketches of Berrien County, volume 4.* Berrien Springs, Berrien County Historical Association, 2001.
Myers, Robert, *Lost in the Lakes.* Berrien Springs, Andrews University, 2003.
Palenske, Fred. *Recollections of Fred C. Palenske.* Transcribed Interview by C. Moulton Davis and Lewis Felstrup, 1968.
Pender, James. *History of Benton Harbor and Tales of Village Days.* Chicago, Braun Printing Co., 1915
Polk's City Directory of Benton Harbor-St. Joseph from 1892 to 1930.
Portrait and Biographical Record of Berrien and Cass Counties, Michigan. Chicago, Biographical Publishing Co., 1893.
Preston, Jr., A. G. *The Banks of St. Joseph.*
Preston, Jr., A.G. *Berrien County Courthouses.* 1978.
Preston, Jr., A.G. *Drake and Wallace or the Story of Silver Beach.* 1992
Preston, Jr., A.G. *Old Benton Harbor and Environs in Pictures.* 1993.
Preston, Jr., A.G. *The Political History of St. Joseph*, 1977.
Purdue, Terry, *Heath Nostalgia*, 1992.
Rackliffe, Anneliza Francetta Sorter. "Reminiscences of Benton Harbor," unpublished paper, date unknown.
Rakstis, Ted. *By the Waters.* Benton Harbor Centennial Association, 1966.
Reber, L. Benj. *History of St. Joseph.* St. Joseph, Michigan, St. Joseph Chamber of Commerce. 1925.
Robinson, Mary. "The Story of Benton Harbor," unpublished paper.
Rockhold, Wanda. *Chips Fell in the Valley.* Benton Harbor, Benton Harbor Centennial Committee. 1966.
Romig, Walter. *Michigan Place Names.* Grosse Pointe, Walter Romig.
Ruth, Rodney McCord. *Grandfathers' Stories of the McCord and Ruth Families.* Undated.

Ryan, Patrick. *History of St. Joseph*. Unpublished paper.
"St. Joseph and Neighborhood Colored Ladies Feast." *The Daily Palladium*, June 6, 1901.
St. Joseph Catholic Church, *A Century of Faith, 1865–1965*.
Savage, David. *Census Guide to Berrien County Michigan Non-White Population, 1830 to 1910*. Three Oaks, 1988.
Schultz, Robert E. *Twin City Trolleys, A History of Street Railways and also Interurbans in Benton Harbor and St. Joseph, Michigan*. Las Vegas, NV, R977.411 1984.
Scott, Madeline Easley, *A Comparison of Two African-American Football Players: 1913 to 1993*. Unpublished paper, 1993.
Shoemaker, Elaine. "Remembering the Flats: Introduction." Unpublished paper, 2002.
Smith, Anita. Ossoli Club Celebrates 100 Years. *Herald-Palladium*, April 15, 1994.
Spencer, Mrs. Irven. "The Higman Park Story." Unpublished paper. 1973.
Strouse, Pat and Bob. *St. Joe Trivia*. St. Joseph, P&B Publishing.
Sykora, Dee. *Edgewater Park in St. Joe*. Unpublished paper prepared for the Antiquarian Society, 1996.
Taylor, R. James. *Mary's City of David*. Benton Harbor, Mary's City of David, 1996.
Taylor, R. James. *200 Years: Joanna Southcott, 1792 through the City of David, 1992*. Benton Harbor, 1992.
Temple B'nai Shalom Centennial Book. Temple B'nai Shalom. 1995.
Thompson, Mark. *Steamboats & Sailors of the Great Lakes*. Detroit, Wayne State University Press, 1991.
Tolhuizen, James A. *History of the Port of St. Joseph-Benton Harbor*. Thesis submitted to the Faculty of the School of Graduate Studies in partial fulfillment of the Degree of Master of Arts at Western Michigan University. Kalamazoo, 1965.
Tyler, Guy M. "City of Benton Harbor: First Annual Report of the City Manager." 1926.
Wade, Stuart. *History of the Morton Family*. 1901.
Walker, Chet with Chris Messenger. *Long Time Coming: A Black Athlete's Coming of Age in America*. Grove Press, 1995.
Walker, Lewis, Benjamin Wilson, and Linwood Cousins. *African Americans in Michigan*. East Lansing, Michigan State University Press, 2001.
Wallace, San Dee. "Walking Tour Demonstrates Historic Area." *Herald-Palladium*, February 10, 1987.
Wallis, Albert. "Memories of Benton Harbor in the Middle '80s, Sixty-Five Years Ago." Unpublished paper. Detroit, no date but about 1950.
Warner, Clarence. *Recollections of Benton Harbor*. Date unknown (before 1957).
Watt, Marilynn. *We'll Hail and Remember*. 1986.
Webster, Mildred and Fred Krause. *French Saint Joseph*. Decatur, George Johnston Graphics, 1986, 1990.
Weissert, Charles. *Historic Michigan, Volume III, Southwest Michigan*.
Winslow, D.A. *History of St. Joseph*.
Zerler, Glenn and Kathryn. *Blossomtime Festival, Southwest Michigan*. Benton Harbor, Blossomtime Inc., 1995.
Zerler, Kathryn. *On the Banks of the Ole St. Joe*. St. Joseph, St. Joseph Today, 1990.
Zerler, Kathryn. *Talk of the Towns*. St. Joseph, St. Joseph Today, 1991.

Web Sites

"Benton Harbor's History." www.qtm.net/benton-harbor/pg02.html
"Benton Harbor Fruit Market." www.bhfm.com/
"City of St. Joseph." www.sjcity.com/history.phtml
"Fort Miami Heritage Society." www.fortmiami.org/priscilla.phtml
"Grand Army of the Republic." www.1upinfo.com/encyclopedia/G/GrandArm.html
"Heathkit Virtual Museum." www.heathkit-museum.com/
"History of Oakridge Baptist Church." www.oakridgebc.org/history.htm
"Lakeland History." www.lakelandhealth.org/communityties/history.html
"Mary's City of David." www.maryscityofdavid.org/
"Peaches in Michigan." www.msue.msu.edu/swmrec/peach/mipeach.htm#History
"Sinbad." us.imdb.com/Name?Sinbad
"The Whirlpool Legacy." www.homelifenetwork.com/whr/corporate/legacy.html
Interviews with: Gladys Peeples Burks, Richard Grau, Ben Mammina, Elaine and Roy Shoemaker, Seymour Zaban, Paul Koehler, William Seabolt, Rev. Donald and Louise Adkins, and Joseph Shurn in July and August, 2003.
Videos: *Centennial Temple B'nai Shalom, 1995; German Immigrant Plaque Dedication, June 17, 2002, St. Joseph, Michigan; Happy Birthday, St. Joe; Recollections from Having Lived a Lifetime on the St. Joseph Beach Area: Virginia Patzer and Henrietta Podolack; Sand Rabbits—Memories—10/26/00* (Presentation at Fort Miami Heritage Center); and *The Flats* (Presentation at Benton Harbor Library, 2002).